Richard Eurich

1903–1992

Richard Eurich
1903–1992
Visionary Artist

Edward Chaney and Christine Clearkin

with essays by Alan Powers and Caroline Toppin and contributions to
the catalogue by James Hyman, David McCann and Peyton Skipwith

Paul Holberton publishing
in association with
Southampton Institute

Acknowledgements

First published 14 March 2003, to mark the centenary of Richard Eurich's birth, by Paul Holberton publishing in association with Southampton Institute
The book accompanies exhibitions in 2003 at the Millais Gallery, Southampton Institute, at the Russell-Cotes Art Gallery and Museum, Bournemouth, and at The Fine Art Society, London

Southampton Institute would like to thank Esso Petroleum for a contribution to the costs of this project

Sponsored by

ExxonMobil

Esso ExxonMobil
Chemical

ISBN 1 903470 11 0

British Library Cataloguing in Publication Data
A catalogue record for this book is available from the British Library

Produced by Paul Holberton publishing,
37 Snowsfields, London SE1 3SU
www.paul-holberton.net

Designed by Roger Davies
daviesdesign@onetel.net.uk

Printed in Italy

Distributed in the UK and Europe by Greenhill Books
(sales@greenhillbooks.com) and in the United States and Canada by University of Washington Press (PO Box 50096, Seattle WA 98145)

SIGNATURE INITIALS IN THE CATALOGUE
CC Christine Clearkin, EC Edward Chaney, JH James Hyman,
DM David McCann, PS Peyton Skipwith

I would like to begin by thanking Eurich's daughters, Caroline Toppin and Philippa Bambach, for their constant moral and material support throughout this project. They have allowed their homes to be invaded on many occasions in search of pictures, drawings or documentations, have generously supplied hospitality and information to miscellaneous visitors, have attended sometimes lengthy meetings at the Southampton Institute, commissioned most of the relevant photography and have been ever available at the end of the 'phone. Graham Bartlett was the original instigator of the exhibition and has proved a patient and supportive manager of the project ever since. Christine Clearkin completed her MA dissertation in Fine Arts Valuation on Eurich in autumn 2002, and from her extremely hard work created the central essay in this catalogue. She also selected the pictures with me, wrote many of the catalogue entries and managed much of the exhibition process. It is doubtful if either exhibition or catalogue would have materialized without her energy and initiative. Principal and Vice-Principal, Dr Roger Brown and Professor Van Gore, instantly appreciated the value of the project and gave it their crucial support. So, too, did Dr Howard Rose, Dean of the Faculty of Media, Arts and Society. Bridget Davis, Curator of the Millais Gallery, managed much of the exhibition itself, with characteristic energy and enthusiasm. Graham Coulter-Smith helped with photography in the early stages. My colleagues in Fine Arts Valuation kindly tolerated my more than usually distracted state, course leader Dr Tim Wilks deserving special commendation for surviving sharing an office with me. The lenders of pictures are all cited in the respective catalogue entries, but we are especially grateful to the Prime Minister and Lord Chancellor and their wives for agreeing to lend us their particularly fine Eurichs. Richard Dorment and Harriet Waugh also loaned an exceptional picture and supplied us with both encouragement and timely information. In the great tradition of the scholar-dealer, James Hyman likewise both loaned and informed. Paul Holberton, who had already done such an excellent job on the catalogue to our exhibition of *Stuart Portraits* at the City Art Gallery two years ago, provided yet more support on this occasion, his editorial assistance going far beyond what one might expect of a publisher. Many of the transparencies were taken especially for the catalogue by John Lawrence. Finally, when funds had all but dried up, Esso, who commissioned one of Eurich's most distinctive works, *The Seven Sisters* (cat. 39), replenished our resources by providing generous sponsorship. We thank all of the above most warmly and very much hope they find both exhibition and catalogue worthy of their labour.

Edward Chaney, Professor of Fine and Decorative Arts
History of Collecting Research Centre, Southampton Institute
December 2002

Contents

Introduction
Richard Eurich: The Complexity of Influence

EDWARD CHANEY

I also began reading, mostly biographies of painters which I still think better and more instructive to artists, both young and not so young, than books about modern movements by authors who are not painters

Richard Eurich, *As the Twig is Bent* (unpublished autobiography, Tate Gallery Archives)

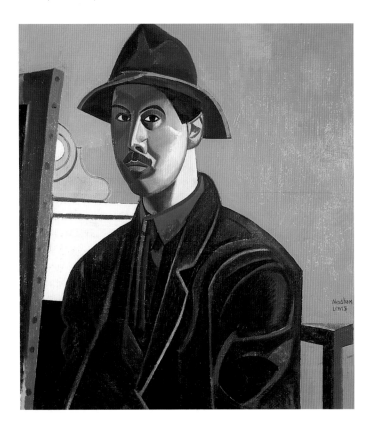

Fig. 1 P. Wyndham Lewis
Portrait of the Artist as the Painter Raphael, 1921
Oil on canvas, 76 x 68.5 cm
Manchester City Art Galleries (Rutherston Gift)

Athough today's modernist or post-modern critics, who could rattle off Tracey Emin's *curriculum vitae* before you could say 'Damien Hirst', may never have heard of him, Richard Eurich was one of the greatest artists of the twentieth century. If the hoped-for revival of figurative painting fails, he may prove to be one of the last in that great tradition stretching back some 30,000 years to the painters of the caves of Altamira, Lascaux and Chauvet. Like the best cave-paintings, the images Eurich created parallel rather than copy nature. His land-, sea- or townscapes tend to feature strangely isolated people, boats or buildings rather than animals (though this catalogue features a magnificent elephant, as well as a cat and mouse; cat. 7 and 36); but Eurich manages to invest these with as much mystery as any bison or rhinoceros frozen in time on the walls of a Paleolithic cave.[1]

In the 1930s, before the more extreme forms of modernism belatedly bullied their way across the Channel (and then the Atlantic), Eurich did rather well with his individualist, intense but visionary style of painting. He was influenced by those aspects of recent French art and thinking on art which were self-consciously primitive in form and expression. In his autobiography he remembers being shown photographs of early Greek carvings and Chinese and Indian sculpture for the first time, "and I realized that this was the Royal line of descent, the feeble imitations of later Greek work being all I knew. I wasn't even sure that Michelangelo was quite as fine now that I had seen these works of earlier civilizations".[2] But he seems to have absorbed all he required from current aesthetics via minimal contact with more active and cosmopolitan spirits. After the Great War, the hitherto most 'advanced' painter in England, Wyndham Lewis (one time *Duce* of the Vorticists), abandoned abstraction, having experienced real-life extremism in the trenches, and concluded that in art as in life there were limits "beyond which there was nothing". He had fully assimilated Cubism in Paris, as well as Futurism and even Expressionism, but, in contrast to his mostly subjectivist contemporaries, he decided to paint and write 'classically', from the outside in, aspiring to reveal the essence of things by describing their exterior with super-natural objectivity. Ahead of his time in his modernism, and now still more isolatedly so in his rejection of most of its tenets, he eventually published a book on *The Demon of Progress in the Arts* (1954).

But Lewis never entirely abandoned what he had learned during his experimental period, his powerfully designed pictures benefiting from Cubism in particular. Eurich, who was twenty years younger than Lewis, seems to have trodden a similar path even before he knew Lewis's work. He encountered Lewis early on in his career, however, in the fascinating private collection of Charles Rutherston.[3] In his unpublished autobiography, Eurich tells us that when he went for drawing lessons at the Bradford School of Art:

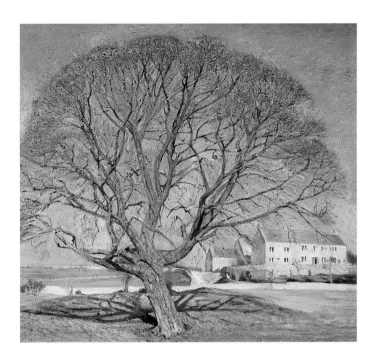

Fig. 3 Richard Eurich
The Tree, 1924
Oil on canvas, 50 x 60 cm
Artist's estate

Fig. 2 William Rothenstein
St Martin's Summer, 1915
Oil on canvas, 84.4 x 91.8 cm
Manchester City Art Galleries (Rutherston Gift)

One day the instructor who was looking through my work said 'Have you been studying Wyndham Lewis?' I had never heard the name but shortly it was to become familiar. Charles Rutherston, the elder of the three Rothenstein brothers lived in Bradford and he invited a few of us to go and see his collection. He had a fine self-portrait by Wyndham Lewis and a lot of his drawings. This collection was an eye-opener. The early [Augustus] John portraits are now famous and these were the first I had seen. Early Paul Nash drawings and a Sickert painting of an interior were all new and a bit strange …. There was one painting in Charles Rutherston's collection which impressed me more than the others. I do not mean that I thought it better than any other. No, it was one of those things which sometimes catch one at the receptive moment and then some urge to do likewise seizes me and a start is made. The painting was of a tree almost bare, a few autumn leaves still clinging to the ends of the branches. It was in bright sunlight, its shadow being cast on the ground in a fan-like pattern behind it. The painting was by Charles Rutherston's brother, Will Rothenstein.

There was a stunted oak tree in our garden at Ilkley. I bought a canvas and laboured in the open air during that summer on a painting of it ….[4]

The William Rothenstein which so inspired Eurich (see fig. 3) was *Saint Martin's Summer* of 1915 (fig. 2). Along with most of the other pictures he saw, this was included in Rutherston's gift to the Manchester

City Art Gallery in 1925. The "fine self-portrait", also now in Manchester, was Wyndham Lewis's 1921 *Portrait of the Artist as the Painter Raphael* (fig. 1), a quasi-polemical call to artistic order:[5] Eurich later enthused about Lewis's *Portrait of Edith Sitwell* in a letter to his friend Edward Wadsworth.[6] The Bradford-born Wadsworth was himself represented in Rutherston's collection by at least one picture, a 1921 tempera of *Portland Village*.[7] So, too, was Joseph Southall, by *Old Seaport (Fowey Bay, Cornwall)* (fig. 4), a remarkable 1919 painting of an almost surreal pale ship against dark water and a proto-Eurichean landscape background. Given such inspiring contents and that Wadsworth anticipated him not only by painting in and around Portland in the early 1920s but by embarking on a series of South Coast harbour pictures at the same time, the Rutherston collection was probably an even more crucial influence on Eurich's development than his autobiography suggests.[8]

In 1938, in an attempt to encourage a compromise between amateurism and avant-gardism Wyndham Lewis submitted his superb portrait of T.S. Eliot to the Royal Academy summer exhibition. Despite his by now well known campaign to qualify extremism in the visual arts, the RA hanging committee rejected it as too modern. Lewis protested with characteristic savagery and Augustus John resigned from the Academy in protest.[9] The following year, however, Eurich had two pictures accepted by the Academy. *The Hampshire Advertiser* for 13 May 1939 subtitled a proud report on 'This Year's Academy' "Hampshire Artist Has Two On the Line". *Solent Fort* (fig. 10, p. 15) and *Staithes* were both praised "in their modernistic spirit" as "notable". Greater

enthusiasm, however, was reserved for the work of "another Hampshire artist. Mrs Olive Snell Pike, of Petersfield … a supremely interesting portrait of Admiral the Hon. Sir H. Meade-Featherstonhaugh, keen of face and alert in pose, dressed in a kind of golf jacket".

Wyndham Lewis might almost have had in mind the *Hampshire Advertiser's* account of the now forgotten Mrs Pike when he published his sardonic account of the unprofessional nature of British art that same year:

As to the Royal Academy, ninety per cent of the annual exhibits are by people of amateur status too – who do not live by their work: they are the work of retired sea-captains, wives of prosperous surgeons, society women, 'stinks' masters at Public Schools, bird-fanciers, stock-brokers. It is a large yearly bazaar of well to do people, who meet and show each other 'what they have done', with a sprinkling of 'professionals' to make it look a real and serious affair.[10]

But Lewis's polemic is directed equally at the avant-garde who, like the RA, drop names into their own exhibitions:

But if this is true of the big official picture parade in Piccadilly, it is also true of the little affairs outside, in the highbrow backwaters of the West-end … two or three big 'professionals' of talent (big mercenaries, as we might call them, like Chirico, Picasso, Dali, or Max Ernst) called in, at a solde, *to lend weight to the enterprise …. When you have received the canvasses of the big stiffs, sent over from the Paris headquarters, you mix them well with the local junk, and you start off with a bang: with a sizeable 'mixed' show.*

If no foreigner was available, "there is Mr Paul Nash - he is a really good local man. And he is a good 'mixer'. You would get him in to bulk out the thin amateur broth."[11]

Like Nash, Eurich was in every sense a professional and could have exhibited in either type of show before the war. Only after the Second World War, with the consolidation of the power of the avant-garde, did Eurich find himself no longer considered 'modernistic' but more exclusively identified with the Royal Academy, of which he became an Associate in 1942 and full Academician in 1953. After several years' hesitation, largely due to opposition from friends and the more radical members of his family, Wadsworth became an ARA in the same year as Eurich. When Wadsworth then tried to recruit the likes of Henry Moore to the Academy, even the unworldly Eurich was sceptical (rightly, as it turned out) about his chances of persuading him. Prompted by the then P.R.A., Sir Gerald Kelly, Eurich himself had already tried to recruit Nash, who rejected the approach, albeit with a "witty reply".[12]

In terms of modern movements, those which are likely to have affected Eurich most significantly were Surrealism and its subtler forbear, Methaphysical painting, which was associated in particular with the highly individualist Giorgio de Chirico, Carlo Carrà and Giorgio Morandi. From the look of Eurich's early, super-real drawings, the Spaniards Juan Miró, Dalí and Picasso may also have been an influence. On the more painterly side, the Fauves, not so much Matisse but Derain and the *intimiste* Bonnard, were likely influences, as is apparent in *The Club Room* (1931; cat. 16). On the whole, however, Eurich seems to have derived such influence via more cosmopolitan painters closer to home, most obviously Christopher Wood, a friend of Lewis's who had met Eurich, but who all too soon killed himself. Mark Gertler, who also committed suicide, was another possible influence. But it was Gertler's contemporary at the Slade and Lewis's former co-Vorticist, the independently wealthy Wadsworth, who would become Eurich's particular friend and correspondent. Like Rembrandt (whom he especially admired), Eurich let his more cosmopolitan fellow countrymen bring back influences as well as pictures from abroad rather than travel extensively himself, assimilating through such connections an extensive range of influences with apparent ease.[13]

Eurich's instinct, perhaps encouraged by Lewis's position, to draw and paint in a modern but figurative idiom served him well at first. In 1928, within a year of leaving the Slade, he was taken up by the enlightened patron Sir Edward Marsh, founder of the Contemporary Art Society, and thanks to this and confirmatory recommendation from Eric Gill he was given his first one-man show at the Goupil Gallery in 1929. From 1933, starting with an exhibition entitled 'Dorset Sea Ports', in a series of sixteen one-man shows lasting until the 1950s, he sold, through the Redfern Gallery, most of what he produced . On the strength of the reputation he had established in the 1930s, in 1940 he was appointed an official War Artist, working mainly for the Admiralty. Specializing in scenes in which the sea featured as a major participant, as a War Artist he achieved a reputation almost equal to those of Paul Nash and Stanley Spencer. In 1941 his masterpiece *The Retreat from Dunkerque* was shown at the Museum of Modern Art in New York in the exhibition *Britain at War*, and was illustrated on the dust jacket and as the frontispiece in the catalogue (cat. 26). After the War, however, a new generation of critics, dealers and patrons called for something more experimental and 'internationalist', which artists such as Ben Nicholson and Henry Moore, even John Piper, seemed willing to provide. Mondrian was hugely influential, and soon the British inferiority complex, having been nurtured since the beginning of the century by the 'Bloomsburies', switched the focus of its attention from Paris to New York, and Jackson Pollock succeeded Mondrian in the smartest magazines and attention-attracting cartoons.

Immediately after the War, encouraged by a growing family, Eurich decided to explore the world of childhood, and exhibited works almost exclusively on this theme at the Redfern in 1945. A better self-marketeer would have rendered the surrealist element in his work more explicit, and thus sold more successfully by identifying his art with an identifiable

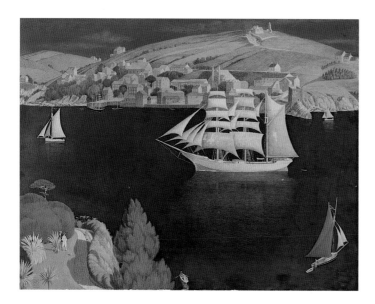

Fig. 4 Joseph Southall
The Old Seaport (Fowey Bay, Cornwall), 1919
Tempera on canvas, 48.9 x 62.7 cm
Manchester City Art Galleries (Rutherston Gift)

movement. Instead Eurich found his idiosyncratic art being marginalized to the extent that he felt obliged to take up a teaching post at Camberwell and accept commissions – from Shell and BP to illustrate their shilling guides (fig. 20, p. 23) and from the Royal Hallamshire Hospital in Sheffield to paint murals (figs. 21 and 22, p. 24). The advent of modernism and the cult for 'contemporary art', increasingly at odds with his artistic integrity and insistence on his personal vision, prevented his post-war career from recovering its pre-war momentum.

After the Second War Wyndham Lewis finally lost patience with pundits such as "the knighted anarchist" Sir Herbert Read who would ignore his later work in favour of his Vorticism. Writing in a style he hoped would appeal to the broadest possible public Lewis attacked *The Demon of Progress in the Arts* and praised those younger British artists we now called 'Neo-Romantics' as the most promising since the Pre-Raphaelites (and praise of the Pre-Raphaelites was itself enterprising in those days). Unfortunately, neither Lewis nor that other great promoter of modern British art, Sir John Rothenstein, seem to have written on Eurich. Even by their discriminating standards his style was too self-effacing, perhaps – too difficult to categorize and thus to promote.

Eurich's reputation has clearly suffered from his never having allied himself to a movement and from his refusal to encumber himself with an easily defined manner. His commitment to his personal vision of nature meant that he passed through a sequence of styles. His later painting in particular is an acquired taste, requiring, in proportion to the enormous trouble he took, a little effort on our part also. Such efforts

are, however, amply rewarded. With every passing Turner Prize it becomes more apparent that figurative painting was prematurely abandoned and that the attention-seeking avant-gardisms that have replaced it do not deserve their dominance.[14] When the artists of this new millennium finally react against the *status quo* and seek to discover where things went wrong, in their quest for earlier twentieth-century models they could do no better than explore the life and visionary works of Richard Eurich RA (1903–1992).

Notes

1 In fact, in his unpublished autobiography (*As the Twig is Bent*, Tate Gallery Archive), Eurich writes of his art-school days: "I have always liked drawing animals and I made a design I called 'The Mad Elephant'; which for some reason caused the other students to view me with respect."

2 *As the Twig is Bent*, Tate Gallery Archives, chapter XX.

3 Charles was the brother of William Rothenstein, the great art educationalist and artist, father of John, the future director of the Tate Gallery, who was to recommend Eurich to Evelyn Waugh (see below, pp. 21). Charles Rutherston gave most of his collection to the Manchester City Art Gallery in order that the works should be available for loan.

4 *As the Twig is Bent*, chapter XX.

5 See Paul Edwards, *Wyndham Lewis. Painters and Writer* (New Haven and London 2000), pp. 264–65, though I believe Lewis is expressing more solidarity with André Lhote's neo-classical campaign here than does Dr Edwards, who takes Lewis's satirical account of the matter (in *The Caliph's Design*) at face value.

6 Barbara Wadsworth, *Edward Wadsworth: A Painter's Life* (London 1989), p. 277. The Edith Sitwell was painted between 1923 and 1936 and is now in the Tate.

7 Ibid., p. 111.

8 See Jeremy Lewison, *A Genius of Industrial England: Edward Wadsworth 1889–1949* (Bradford 1990), pp. 42–45. Eurich notes, "Charles Rutherston was very generous in lending both pictures and books to the school [in Bradford]. Among the books was Blake's 'Job' and his engravings for Blair's 'The Grave'. This I found engrossing and I made what I thought were analytical drawings from them. Giotto also suffered this fate but I certainly began to learn something about the rudiments of design"(*As the Twig is Bent*, chapter XX).

9 Unable to find a British buyer, in 1939 Lewis sold his portrait of Eliot to the Municipal Art Museum in Durban, South Africa for £250. John's portraits then commanded up to £3000: see Edwards, *op. cit.*, pp. 466–70.

10 Wyndham Lewis, 'Super-nature versus Super-real', in *Wyndham Lewis the Artist. From Blast to Burlington House* (London 1939), p. 35.

11 Ibid., pp. 36–37.

12 Wadsworth, *op. cit.*, p. 319. Nash's 1943 reply to Eurich is in the Tate Gallery Archives, 8813.124. He revealed that Sir William Rothenstein had already suggested his becoming an RA some years earlier.

13 His daughters believe that, like Stanley Spencer, Richard Eurich never visited Italy. For Eurich's choice of the two best pictures in the Dresden Gallery, which he visited as a boy with his father, both Rembrandts, see *As the Twig is Bent*, chapter XIX.

14 E. Chaney, 'Kitaj versus Creed', *The London Magazine*, April/May 2002, pp. 106–11.

Richard Eurich:
His Life and Career

CHRISTINE CLEARKIN

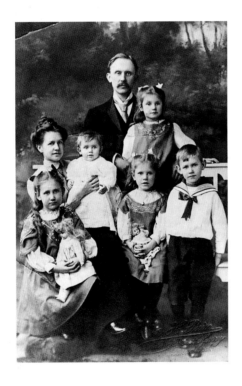

Fig. 5 Family portrait photograph, Christmas 1910
From left to right: Margaret, Mother, Hugh, Father,
Evelyn, Guendolen and Richard

The difficulty in assigning Eurich to a particular group or movement among his contemporaries has proven insurmountable for critics and art historians alike.[1] His resistance to categorization is the predominant reason why his art is not better known and appreciated. His style of painting owed much to the age into which he was born, and yet he saw himself in the tradition of great British artists that began with Hogarth. The breadth of his oeuvre extends from his (best-known) seascapes and coastal views to detailed townscapes, capricci and sweeping landscapes. His creative urge and curiosity were so constantly irresistible that Eurich did not lapse into pastiches of his most popular work but instead continued to experiment into old age. Bernard Dunstan, a fellow Royal Academician, has observed:

Altogether his range of subject matter and treatment is far wider than that of most of his contemporaries, most of whom had settled down by early middle age to a manageable area of subjects and a recognisable style – as is, in fact, the normal sequence of a painter's development. Eurich never settled down in this way.[2]

Richard Ernst Eurich was born on 14 March 1903 in Bradford. He had a happy and secure childhood, according to his unpublished autobiographical fragment, *As the Twig is Bent*. He grew up in Bradford and later Ilkley with his three sisters and one brother (fig. 5). His father, who had been a general practitioner and later became Professor of Forensic Pathology at the University of Leeds, has gained a prominent place in the history of medicine for his research into the causes and treatment of anthrax. The family came originally from Germany, Eurich's grandfather having emigrated in the mid-1870s from Zittau in Saxony partly because of his unease about the growing militarism of the country under Bismarck. He later became a naturalized subject of the British Crown.[3] Eurich's maternal grandfather was an Anglican clergyman whose family had lived and farmed in Yorkshire for generations.

Music was a pleasure common to the whole family, and in his early teens it seemed as if Eurich might take up organ building as a career. This idea was superseded as a result of growing evidence of his ability as an artist, which led instead to his receiving a formal art education.[4] The influence that music had upon his art is most noticeable in the drawings shown in his first solo exhibition, at the Goupil Gallery in London in 1929, such as *Lady with a Lute* (cat. 8).[5] The influence of music can also be detected in the rhythm and balance of his later paintings. While he painted, Eurich liked to listen to classical music on the radio or, alternatively, during the cricket season, to John Arlott's commentaries. In his latter days he preferred silence, possibly because of a growing problem with deafness. He was an accomplished pianist and after he had settled in Hampshire would frequently play the organ for evensong at Beaulieu Church. His younger daughter, Philippa Bambach, has continued the musical tradition and plays both the bassoon and the flute.

Fig. 6
Battleship and Submarine, 1915
Watercolour on paper, 9 × 12.5 cm
Artist's estate

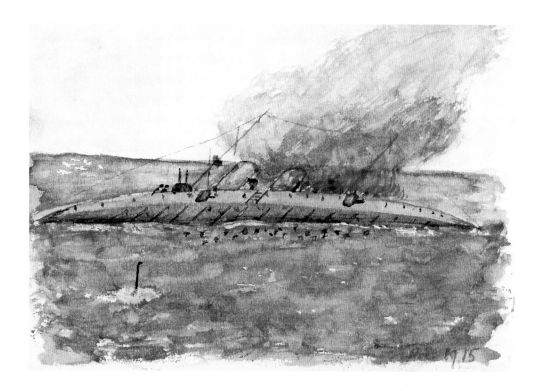

Eurich was not academically inclined at kindergarten, so in 1913 his parents resolved to send him to a boarding school at Harpenden in Hertfordshire, where they hoped he would benefit from intensive tutoring. Instead his time at the school proved a desolating experience, made worse by the outbreak of the Great War, which made the possession of a Germanic name an open invitation to be bullied.[6] While a pupil at the school Eurich showed some aptitude for art, the only subject he enjoyed, and he won a prize for drawing.[7] Apart from one distant relative, August Eurich (1813–1850), who had specialized in miniatures, no other member of the family was known to be artistic.[8] The few extant examples of his work from this time (fig. 6) show a preoccupation with images of war on land, sea and air, but this was probably typical for all boys of his age during the Great War.

Eurich was relieved when his wretched time at boarding school came to an end in 1918, though it had made its mark. His single-mindedness, so much a feature of his later artistic career, and his personal reticence can perhaps be partly attributed to his unhappy time there. His pacifist convictions were more probably influenced by his parents' affiliation to the Society of Friends, or Quakers.[9] Back in Bradford he was enrolled at the Grammar School and completed his education there as a day pupil.

It was at the Grammar School that Eurich's artistic talent was first taken seriously, and he won a scholarship to Bradford School of Arts and Crafts.[10] His time there (1922–24) proved a disappointment to him, since the course was orientated towards commercial rather than fine art, requiring the design of "posters and labels for boot boxes, book jackets and some book illustrations".[11] He did, however, benefit from his course in one respect, drawing from the Antique, which gave him an appreciation of the sculptor's art and a greater facility to describe three-dimensional form on a two-dimensional surface.[12] The head of the painting department thought there was no livelihood to be made in fine art and recommended that Eurich become a teacher, but relinquished this idea when he saw the quality of some of his paintings.

Eurich went on to complete the course at Bradford and then, with the benefit of a grant, took up a place at the Slade School in London (1924–26).[13] This, too, proved something of a disappointment, not least because his artistic hero, J.M.W. Turner, was held in disdain by his contemporaries, influenced as many were by Roger Fry and Clive Bell with their Francophile views. He took full advantage of being in London, however, and studied the work of the masters at the great museums and galleries, while also taking an interest in non-European sculpture, especially from India. While at the Slade he won seven prizes for drawing and composition and his capacity to draw both from life and imagination formed the basis of his early career, leading to his first one-man exhibition. While still a student he successfully exhibited with the London Group, and in 1927 he won a Young Artists Competition run by *The Daily Express*, which resulted in his work being hung with that of Paul Nash, Mark Gertler and John Armstrong.[14]

Eurich maintained that he did not paint in oil at all during his time at

Fig. 7
Study for Decoration, 1928
Pencil on paper, 50.5 × 30 cm
Southampton City Art Gallery

the Slade, but concentrated instead on drawings. He later recalled:

What I saw of the painting in the school horrified me; all smooth gradations of tone without a sign of any colour and completely lacking in vitality. I decided I wouldn't paint there and kept on with drawing.[15]

On one occasion Professor Tonks asked him why he was not painting: Eurich replied that he simply preferred to draw, and "as drawing was the one thing he [Tonks] believed in I knew he would not pester me any more".[16] Eurich did paint in his lodgings, however, and submitted these pictures to the Slade's monthly 'Sketch Club' that was open to all students other than first-years. He recorded the details in his autobiography:

Once a month this club held a show of compositions painted out of school. A criticism was given by Professor Tonks or another instructor and about three prizes of a guinea each were awarded …. I was very astonished when I was awarded first prize for a figure composition …. During my last term I was awarded a prize every month which was very gratifying.[17]

In 1928 he sold a watercolour, *Bedroom Interior*, to the renowned

connoisseur and collector Sir Edward Marsh (1872–1953).[18] Sir Edward, who was Churchill's secretary and served on the committee of the Contemporary Art Society, subsequently made his way to Eurich's lodgings and bought a small oil painting, *The Broken Tree*, for £5.[19] He also took the opportunity to inspect Eurich's other work and was sufficiently impressed to enlist the help of Eric Gill. Together Gill and Marsh were instrumental in arranging Eurich's first one-man exhibition, which took place in December 1929, just two months after the Wall Street Crash.[20] Thus, at the precocious age of twenty-six, Eurich's career was launched in a solo exhibition at the Goupil Gallery in Mayfair. Among the luminaries of the British art scene attracted to the exhibition was Christopher Wood, whose influence upon Eurich is apparent in paintings produced during the early 1930s such as *The Club Room* (cat. 16). Wood also gave Eurich the sound advice to "paint what you love and damn all fashions which come and go".[21] Henry Tonks, Professor of Fine Art at the Slade and his former tutor, also visited the exhibition and suggested that he might consider becoming an engraver, an idea that he did not take up.[22] The exhibition received a good notice in *The Times*, and Eurich made five sales, one of which was *Study for Decoration* (fig. 7), bought by Sir Edward Marsh.[23] At the time he was anxious lest he fall into debt because the gallery had made it clear that they expected payment of £20, a sum equivalent nowadays to £600, in return for their outlay on publicity and printing. Since he was so hard up that he was unable to pay in advance, the arrangement was that they would deduct the sum from his first sales, "after which their usual commission would come into operation". Eurich recalled that he "could not help wondering what would happen if there were no sales", but happily he never found out.[24]

After 1929, however, he forsook the production of drawings as completed works of art for the dual reasons of health and economics. He had developed eyestrain as a result of his meticulous work and the ophthalmic specialist he consulted soon after the exhibition strongly advised him to concentrate on painting in future if the damage were not to become permanent – advice that he took.[25] He also realised that labour-intensive drawing was an uneconomic use of his time, because of the "absurd method of pricing pictures by size and medium".[26]

Eurich possessed a powerful sense of spatial awareness and could form the plan of a place by walking around and considering it from different views. He had the capacity to imagine how a particular scene would look from an elevated but inaccessible viewpoint, a feature that he employed in many of his Second World War paintings. He disapproved of cameras, preferring to trust his own judgement in the selection of detail.[27]

Eurich's visual memory and his grasp of composition were unusual gifts, even among artists. In the Royal Academy on one occasion the President, Sir Gerald Kelly, was teaching a group of students. In order to illustrate a particular point he turned to a large work by Eurich, *Queen of the Sea, 1911* (1954), and asked the artist to confirm that he had made

extensive underdrawings for the work. Eurich later recalled:

It was rather embarrassing to admit that I had just painted it that way from one side of the canvas to the other. In fact I have no idea how to 'square up'. The only time I ever had to do it was for a mural [for a new teaching hospital in Sheffield], *and then my eldest daughter did it for me.*[28]

These qualities of draughtsmanship, spatial awareness and a reliable visual memory underpinned Eurich's whole artistic career; and, together with a visual imagination and that indefinable quality which distinguishes an artist from a copyist, were the skills that combined to make his work unique among his contemporaries. Many of Eurich's war paintings were executed on the basis of reported information only, though sometimes he was given access to maps and briefing material.[29]

Richard Eurich had early on discovered the work of J.M.W. Turner and his admiration of his work was to endure throughout his life.[30] While still a novice artist he endeavoured to paint *en plein air* but on occasions found the elements so fierce that he preferred instead to distil the essence of a scene in notational form. The work of Dürer, too, made a strong impression upon Eurich, notably during a visit to the Gemäldegalerie in Dresden during the early 1920s.[31] He was especially influenced by his watercolours, because of their freshness, and because

they had captured something of the timelessness of the east German countryside.[32] Eurich admired the great naval artist Willem van de Velde, too, and saw himself as continuing his tradition when volunteering in 1940 to paint the epic evacuation of the British Expeditionary Force from Dunkirk.[33] But while a student at the Slade Eurich had experimented with several styles, and his emulation of Cézanne had met with the disapproval of Professor Tonks.[34] Indeed he assimilated many of the lessons of modernity in his compositions and presentation, and admired the work of his slightly older contemporaries Mark Gertler and Christopher Wood, but he was not a man for fervent allegiance to any one style of art, selecting only those elements that best helped him achieve what he envisaged.[35] He always remained conscious of his place in the great tradition of European representational art.

The extent to which Eurich was influenced by Christopher Wood's work is most apparent in the collection of paintings shown in his second one-man exhibition, 'Paintings of Dorset Seaports', in 1933 at the Redfern Gallery, to which Sir Edward Marsh had also introduced him. Like Wood, Eurich sometimes adopted the palette knife in preference to the brush as a means of loading paint on to his canvas, as in *Lyme Regis* (1930; fig. 8), but the results, although attractive, did not always carry conviction, and Eurich can be seen at this point still to be seeking his personal style. *Golden Cap* (1932; cat. 19), bought by the artist's proud

Fig. 9
French Trawler at Weymouth, 1934
Oil, 51 × 61 cm
Private collection

father, was among the paintings on show, as was *Still Life, Lyme Regis* (1933; cat. 21). The exhibition proved an "unqualified success" and the Redfern offered Eurich a contract to act as his London dealer; in the course of the next twenty-five years they were to organize fifteen further one-man exhibitions. As his popularity expanded and his income grew, he found himself in a sufficiently secure financial position in 1934 to marry his sweetheart and fellow artist Mavis Pope.

Richard and Mavis Eurich found that property prices in London were beyond their means, so they moved from their lodgings in 19 Coleherne Road SW10 to Dibden Purlieu, on the edge of the New Forest, as soon as a new cottage had been built (fig. 36, p. 41). They named the house after the village of Appletreewick in Yorkshire. From its elevated position Eurich could observe all the shipping movements in and out of Southampton docks. He painted in his studio there for the rest of his life, initially in a garden shed and later, after the War, in an annexe to the house. He would work in his studio seven days a week. By moving to rural Hampshire, however, Eurich took himself out of the London milieu where artists were usually keen to remain, networking and vying for the favourable attention of the most influential figures in the capital's art world.[36] His relative isolation would have repercussions after the Second

World War, when, more than ever, networking was a necessary part of life for any ambitious artist. On the other hand, it was thanks to this relative isolation that he was able to concentrate on his work and explore his particular and idiosyncratic vision of the world. In a letter to his friend and patron Sydney Schiff he wrote:

I am one of those artists who has to get shut up and brood and get into a state of mind which takes great effort, and then there is all the hard work. I think that if one has quiet, and have the courage to start work and concentrate, that the interest comes; the inspiration or whatever one likes to call it being something quite subconscious that has been experienced perhaps years ago.[37]

By 1936 the resemblance between Eurich's 'faux naïf' work, a typical example of which is *A French Trawler at Weymouth* (1934; fig. 9), and that of Christopher Wood was no longer obvious. He continued to be interested in ships and harbour scenes, and the detail that had been a noted feature of his early drawings was now very much a part of his paintings; at the same time his handling of colour had become more assured. His ascending prices would seem to confirm that his work, and

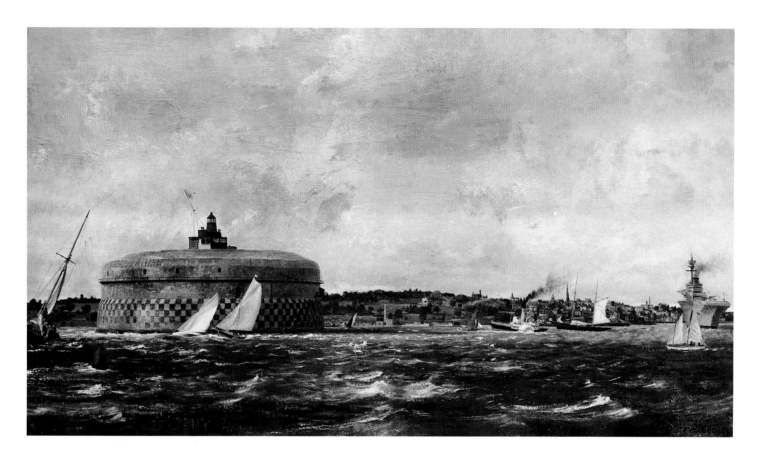

Fig. 10 *Solent Fort*, 1936, oil, 102 × 127 cm, private collection

his own particular style, were being appreciated. In his 1936 solo exhibition his most expensive painting, *Solent Fort* (fig. 10), was priced at 100 guineas, while in the 1933 exhibition his most expensive painting, *The White Ship, Lyme*, had been priced at 25 guineas.

Eurich's reputation also spread abroad after he was selected with several others to represent Great Britain in the 'International Exhibition of Paintings' at the Carnegie Institute, Pittsburgh, between 1936 and 1939.[38] The other British artists with whom his work was displayed included Stanley and Gilbert Spencer, Stephen Bone, Ivon Hitchins, Claude Rogers, Winifred Nicholson, John Piper, Augustus John and Duncan Grant. The catalogue for his 1938 solo exhibition was, for the first time, illustrated, suggesting the strength of the Redfern's confidence in the saleability of his work. An article in *Art Review* on 'Exhibitions of the Year' stated that "Richard Eurich registered such a decisive advance on even the best of his previous work that one does not hesitate to mention him" in the company of Sir William Nicholson, Philip Connard, Bertram Nicholls, Lamorna Birch and Paul Nash.[39] A painting from this exhibition, *Porthleven, Cornwall* (fig. 12), originally bought by Dudley Tooth, was sold to the National Gallery of Victoria, Melbourne in 1945.[40]

When, in 1939, Britain was obliged to declare war on Germany,

Eurich initially thought he would have to give up painting for the duration. At thirty-six he was too old to be called up, so he volunteered to work as a part-time ambulance driver and Air Raid Protection warden, supplementing his hours milking cows on a nearby farm.[41] As the period of the 'phoney war' wore on, so Eurich became determined that he would continue to paint. It is implicit in a letter from Edward Wadsworth that he had expressed interest in becoming an official War Artist.[42] The work of the War Artists of the 1914–18 War was widely known and admired; many of them were still alive, including Edward Wadsworth himself, Paul Nash and Stanley Spencer. Since he knew well what would be required of him as an official War Artist, there must have been a certain tension in Eurich's mind given his Quaker sympathies and pacifist convictions, and the fact that his second and third cousins still lived in Germany.[43] Eurich was duly summoned for interview in Whitehall in April 1940.[44] He was, however, disappointed with his first two commissions, for which he received £50 plus a flat-rate allowance for expenses, but in the event the War Artists Advisory Committee (WAAC) were so impressed with these paintings that an honorarium of £10 10s per picture was added "in view of the excellence … and the amount of work" that had gone into them.[45] The paintings were worked

in different styles: *Robin Hood's Bay in Wartime* (fig. 11) was painted in a precise manner while *Fishing Boats at Whitby Bay* (fig. 13) had looser brushwork. Both paintings underplayed the theme of war, and *Robin Hood's Bay* even included an overt reference to Eurich's pacifist convictions in the two fishing boats named *Peace* and *Good Samaritan* respectively. This precise style of painting was the one that Eurich was to favour for the majority of his other war paintings, another example of which can be appreciated in *December, Work Suspended* (1940; cat. 25). In several of his war paintings he paid homage to Turner, not least in *Bombardment of the Coast Near Trapani* (1943; cat. 28), in which the belching flames from the ships' guns recall many a Turneresque sunset. Similarly, in *The Midget Submarine Attack on the Tirpitz* (1944; cat. 30), the contrasting sunlit mountain peaks and the plunging inky depths of the fjord, populated by a startled sea monster, rejoice in that quality of light which was so important to Turner.

It was a source of regret to Eurich that during the war his official work had taken up so much of his time that he had had little opportunity to paint more personal subjects. In a letter to Sydney Schiff he wrote, "My salary demands that I turn out a quantity of paintings, and so I find myself quite unable to promise anything to anybody, because if I did I should be worried to death with so many things wanting my attention".[46]

As early as October 1943, however, Eurich began to think in terms of undertaking a series of paintings for children despite his obligations to the Admiralty. In a letter to Schiff he wrote:

I am just starting to paint at odd moments a set of little pictures as Christmas presents for some of my nephews and nieces, and it has put into my mind a scheme which might interest Nan Kivell: That is to hold a one man show of small paintings specially painted for children priced at very reasonable prices. I have always wanted to indulge in free fancy and humour occasionally and this seems to be a good way of liberating it, besides giving a freedom and opening up ideas in more serious work.[47]

The idea of the exhibition was apparently welcomed by Rex Nan Kivell at the Redfern Gallery, but progress was painfully slow, Eurich complaining in May 1944 that he had been unable to do any so far that year, with the result that "the projected show will have to be put off for some time".[48] By April 1945, however, he had completed thirty-one small pictures which were brought together for a solo exhibition. The paintings had titles that would appeal to a childish imagination, such as *House by the Beach* (cat. 31), *Eclipse of the Sun* and *The Leopard*. The prices were modest, too, ranging from eight guineas for *The Goods Train* to eighteen guineas for *Farmyard*. In a review Eric Newton remarked:

Fig. 12 *Porthleven, Cornwall*, 1937, oil on canvas, 50.4 × 178 cm
National Gallery of Victoria, Melbourne (Australia), purchased 1945

Fig. 13 *Fishing Boats at Whitby*, 1940, oil on canvas, 38 × 76 cm
National Maritime Museum, London

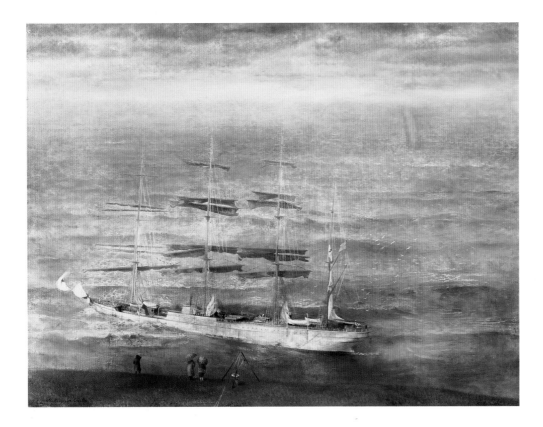

Fig. 14
The Wreck of the Herzogin Cecilie, 1944
Oil on canvas, 77.5 x 101.5 cm
Southampton City Art Gallery

There is no nonsense about these pictures but there is plenty of queerness
…. Each picture tells its story crisply, provokingly and economically ….There
is no stooping to nursery level here: there is merely a deliberate
concentration on the kind of objects that are important to children.[49]

An element of Eurich's "free fancy and humour" evident in these
paintings may have been his personal response to the introduction of
Surrealism to Britain at the London International Surrealist Exhibition in
1936, with its combination of methodical detail and unexpected
conjunctions. His interest in childhood was undoubtedly the result of
having two young children at home, to be joined by a third in 1947.

Meanwhile, in spite of these experiments, he continued to tackle
serious subjects, a remarkable but rarely seen example of which is *The
Wreck of the Herzogin Cecilie* (1944; fig. 14).[50] The war was changing
Eurich, not only because it was antipathetic in itself but also because it
brought the additional horror of the Nazi concentration camps. In
December 1942 Eurich confided in Sydney Schiff, who was Jewish, how
deeply affected he was by what he had read about these camps:

*Since I last wrote I have painted another very small work, or rather a study,
of Jews in a concentration camp. The painting of it is almost like a
watercolour, transparent and no solid white used, except for the white*

*ground on which it is painted, and since this little effort I have been reading
Feuchtwanger's* The Devil in France *being his experiences in concentration
camps during the first six months of the war, and I felt I had got very much
the feeling into my painting of some of the men he describes.*[51]

The subject had affected Eurich deeply and he wrote again to Schiff in
June 1943:

*But you have no idea how much I value your letters and advice on whatever
they contain. You see, I am now at the most difficult mental stage of all,
youthful confidence and any exuberance that there may have been has
gone, and very serious problems are ahead, all of which is complicated by
my present job, and it looks as though I shall inflict you with a long story of
my difficulties sooner or later. You are the only being I know who can help me
or perhaps endorse my own feelings so that I can be more sure of them.
Would you be very good and let me lend you a small painting? It seems the
only thing I can do to show a little of my feeling.*[52]

Eurich had painted a second picture on the subject of the concentration
camps, *From Dachau* (fig. 15), and it was this painting that he loaned to
Schiff.[53] These paintings were solely the result of Eurich's meditation on
the subject and yet the picture he loaned to him was so searing that it

had to be kept turned to the wall. Schiff described it as "a masterly portrait" and asked Eurich where he had found this "specimen of human suffering".[54] Eurich replied:

I must now answer your questions about the Dachau picture. I don't really know where the idea or the face itself came from, 'out of my own head' is the usual phrase, but no doubt it started somewhere far back. In this one and in the other I painted of several heads together I tried to avoid any momentary action, just the contemplation of a lifetime's persecution, in fact down the ages. Small as they are these paintings seem to have stirred a few people I am sorry if the picture causes unpleasant feelings, but I knew you would understand it, and I really haven't anything else I would care for you to see.[55]

When, after the War, Eurich turned to other subjects, this was not a superficial flight from reality but rather the act of someone who, fully conscious of evil and suffering in the world, sought to offer a new and different vision that might act as an antidote to these afflictions. He was also conscious of the joy of having a young family and the pleasure of watching each of them achieve their milestones. When the war was over he would address subjects on a human scale rather than the epic themes that he had taken on during it: he would paint towns and seaside resorts, nursery stories and rural landscapes. Strangely, David Sylvester, the critic who lauded Francis Bacon's work precisely because it seemed to express the despair of the post-war world, had little time for the kind of representational art that Eurich produced, which is perhaps why he might be one of the figures in the uncharacteristically satirical painting *The Critics* (1956; cat. 34). Eurich was careful never to name the men he had caricatured, although their names can be guessed (see further p. 68).

Eurich thought that critics, on the whole, had a baneful influence over fashions in public taste and that the passage of time was usually the best arbiter of quality. He maintained that the most reliable guides for him were the Old Masters, from whom an attentive student could learn almost all he needed to know about art, whether it be form, composition, colour theory, or the application of paint.[56] At a time when modernist critics were emphasizing the 'impersonality' of great art, he believed that more could be learned from reading an artist's biography than from "books about modern movements by authors who are not painters".[57] While he maintained his artistic integrity by standing aside from all artistic fashions, he did consider himself "influenced strongly by contemporary thought and painting", always *within* the tradition of Western figurative art.[58] When Eurich found it increasingly difficult to sell his paintings after 1945 he resisted the temptation to make his art more fashionable in order to pander to critics who favoured the avant-garde, because he felt that this would have involved turning his back on five hundred years of accumulated artistic wisdom.

Fig. 15 *From Dachau, 1942*, 1942
Oil on board, 26.8 × 17.6 cm
Artist's estate

One welcome novelty for Eurich that resulted from his rôle as an official War Artist had been a regular salary. Hitherto his income had been derived solely from the sale of his paintings – a precarious means of livelihood at best and one that had caused periods of financial strain.[59] By 1945 he had two children and he once again faced the prospect of earning a living by self-employment. To begin with the transition was eased by commissions from several major institutions to record various official events, but Eurich was temperamentally unsuited to work within tight prescriptions and he rejected further similar work after 1946, still confident that he could gain his livelihood by sales of uncommissioned paintings directly to the public.

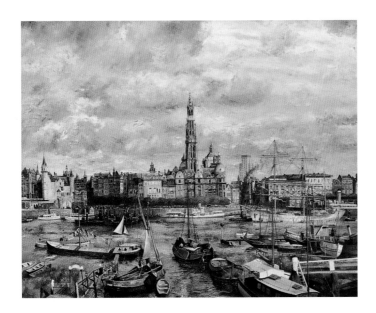

Fig. 16 *Antwerp*, 1939
Oil on canvas, 101.5 × 127 cm
Tate, London

Britain, of course, was deeply in debt after the War, and the years 1945–50 came to be known as the 'Age of Austerity' because rationing became even more severe than during the war itself. The country was saved from economic collapse only by the implementation of the Marshall Plan, and it was not until 1954 that food rationing was finally ended. With the critical state of the economy, there was little spare cash for anyone to spend on paintings and Eurich, like many of his contemporaries, had difficulty selling his work.

In 1949 he held another solo exhibition at the Redfern Gallery, but the income from his market had, by now, become too haphazard to sustain him or his family. He was, therefore, grateful that year to accept the offer of part-time employment at Camberwell School of Art extended by the new Principal, Leonard Daniels. He was to remain there, working two days a week, until 1968, when he gladly took retirement. Having a steady, if modest, income from his part-time work enabled him to continue to paint according to his inspiration during the rest of the week.

During the 1950s Eurich wrote an autobiographical fragment, *As the Twig is Bent*, which recounts his life from his earliest childhood memories to the day when his first one-man exhibition opened at the Goupil Gallery in November 1929.[60] There was a tradition on both sides of his family of writing memoirs for the benefit of future generations. There had also been a recent literary trend, most evident during the War, for authors and other artists to write about their childhood, and Eurich, who was an avid reader, would have been conscious of it.

His experiments with "free fancy and humour" continued and he produced a series of other paintings that were inspired as much by recollections of his own childhood as by watching his own children grow up.[61] *A Hot Day in the Village* (cat. 35), shown at the Redfern in 1952 and sold the same year, reveals this gentle humour. On the whole, though, these paintings were markedly less popular and some took years to sell – for example *The White Horse, Kilburn* (1949), finally purchased in 1977 by a private collector; *The Mummers* (1952; cat. 33), a capriccio that evoked a scene from his youth in Bradford, bought by Hove Museum of Art in 1978; and the very large *York Festival Triptych* (1954), finally sold to a private collector in the 1970s. *Floodwater* (1954–55), too, was still unsold in 1968 when it was exhibited at Tooth's, and numerous other paintings by Eurich were relegated to his studio for a decade or more until the market was ready to accept them.[62] With the conclusion of his rôle as an official War Artist and the abrupt change in the subject-matter of his paintings, he seemed both to have lost his pre-war clientele and to have failed to capture a new market.

By 1958 Eurich was sufficiently concerned about the situation to write to Nan Kivell at the Redfern Gallery and ask why his paintings were not selling. Although his letter is no longer extant, Nan Kivell's reply admitted that his own taste had changed with that of the public towards pictures in the modern idiom, though he was mystified why the market for figurative artists should have failed. He continued:

I am as you know, deeply disappointed that I cannot get more success with your exhibitions and I am wondering whether it is that we have oriented our clientele too far towards the new idiom …. I do want to do my best for you because you know how much I appreciate your friendship and your most loyal attachment to the Redfern.[63]

Eurich resigned his contract with the Redfern later in 1958 and dispensed altogether with the services of a London dealer for the next ten years.

While the market for Eurich's paintings dwindled, paradoxically he was still recognized on a national level as a leading artist. In 1942 he had been elected an Associate of the Royal Academy and in April 1953, on the acceptance of his diploma work, *The Mariner's Return* (fig. 17), he became a full Academician.

In 1950 Eurich was again invited to contribute a painting to the 'International Exhibition of Paintings' at the Carnegie Institute, Pittsburgh. Although he represented his country in this forum, it is surprising that he was not asked to contribute to the 1951 Festival of Britain exhibition of contemporary British artists in London. Instead a major retrospective exhibition of his work was held at Bradford City Art Gallery, Cartwright Hall, as part of the Festival of Britain celebrations there.

The national profile provided by membership of the Royal Academy, and the memory of Eurich's paintings for the Admiralty during the War,

Fig. 17 *The Mariner's Return*, 1953, oil on canvas, 63.5 × 76 cm, Royal Academy of Arts, London

which had been much admired, were sufficient to attract commissions from various large organizations during the 1950s and into the mid 1960s. These commissions came with acceptably broad-phrased requirements from organizations as diverse as the General Post Office, Esso, Shell and Sheffield Hospitals Board. An eccentric individual commission came in 1951 from Evelyn Waugh, on the recommendation of Sir John Rothenstein. Waugh, a pioneering connoisseur of Victorian art, owned two paintings by Thomas Musgrave Joy on the pleasures of

travel in 1751 and in 1851 respectively, and wished to have a third to bring the series up to date (fig. 18). He was very specific in his instructions and wanted the painting to show "a Dakota crashing and the passengers being burnt".[64] Rothenstein showed him Eurich's *Survivors from a Torpedoed Ship* (1942; cat. 29), which satisfied him that he was the best artist for the commission. The painting was completed by 1953 and Waugh was delighted with the result: "Your picture is framed & hung & looks very beautiful, but it does need varnish and also I would be

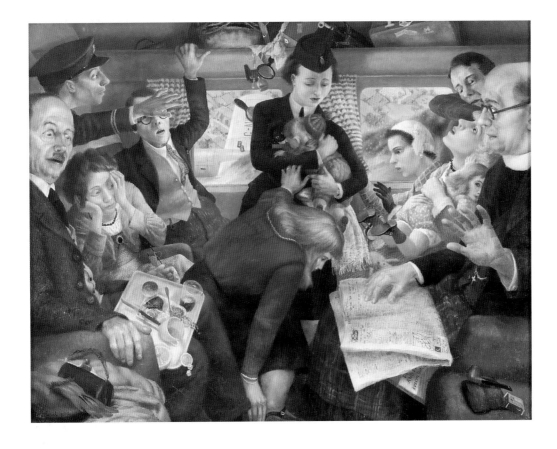

Fig. 18
The Pleasures of Travel, 1951, 1953
Oil on canvas, 50.8 × 63.5 cm
Private collection

grateful for a few flames in the foreground".[65]

There is an interesting postscript to Eurich's contact with Waugh: some five years later, Waugh read his autobiographical fragment, *As the Twig is Bent*. Even though he criticized the manuscript, he did so with uncharacteristic tact and offered to write a preface and also to help with the task of finding a publisher, but in spite of this offer the book was never published.

Several one-off commissions followed, including a painting of the Queen's coronation in 1953 for an illustrated newspaper and another in 1956 to commemorate the re-dedication of Rouen Cathedral, after its virtual destruction during the battle for Normandy in the Second World War. This was possibly linked to Eurich's former rôle as an official War Artist, since he sailed up the Seine in a Royal Naval ship to undertake the commission. It seems that two versions were painted, one with the rebuilding work completed, *Rouen, 1956* (fig. 19) and the other with it still in progress, *Rouen Resurgent* (1956). A third related painting, *Porte Guillaume Lion, Rouen*, was also completed in 1956.[66]

In 1958 the General Post Office approached Eurich to paint a poster for their 'correct addressing' campaign. He was one of a number of leading British artists commissioned to contribute to this long-running campaign and the posters would have been displayed in post offices

throughout the country. Eurich's contribution (cat. 37) shows a boy overlooking a snow-clad Richmond in Yorkshire with a map of the town in his hands. The boy is probably a self-portrait, recalling Eurich's youth in Yorkshire.

As the national economy began to revive during the late 1950s, in response to the growing market for leisure motoring, BP and Shell collaborated in the production of a series of shilling guides to the British countryside. Almost all the leading figurative artists of the day, Eurich among them, were commissioned to produce paintings for these guides. The three he painted were *Cornwall* (1958), *Caithness* (1961) and *Anglesey* (1963), and later he was asked to do two paintings for the shilling guide to bird sanctuaries, *Farne* (1965) and *Calf of Man* (1965; fig. 20). These five paintings remained in the Shell Art Collection until July 2002, when they were offered for auction at Sotheby's Olympia.

While he was between commissions, Esso Petroleum approached Eurich to paint a view of their new refinery at Fawley in Hampshire. The resulting picture, *Seven Sisters* (1960; cat. 38), referring to the seven liquid petroleum gas tanks on the right, shows not only Eurich's fastidious attention to detail, a feature apparent in his War paintings, but also his enjoyment of curious juxtapositions, here a cyclist pedalling through one of the most technologically advanced industrial sites in the realm.

Left
Figs. 18a and b Thomas Musgrave Joy
The Pleasures of Travel, 1751
The Pleasures of Travel, 1851
Private collection

Right
Fig. 19
Rouen, 1956
Oil; support and dimensions unknown
Private collection

Below
Fig. 20
Calf of Man, 1965
Tempera on board, 34 x 52 cm
Formerly Shell Advertising Art
Collection

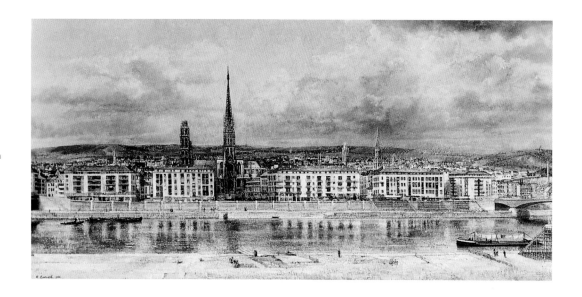

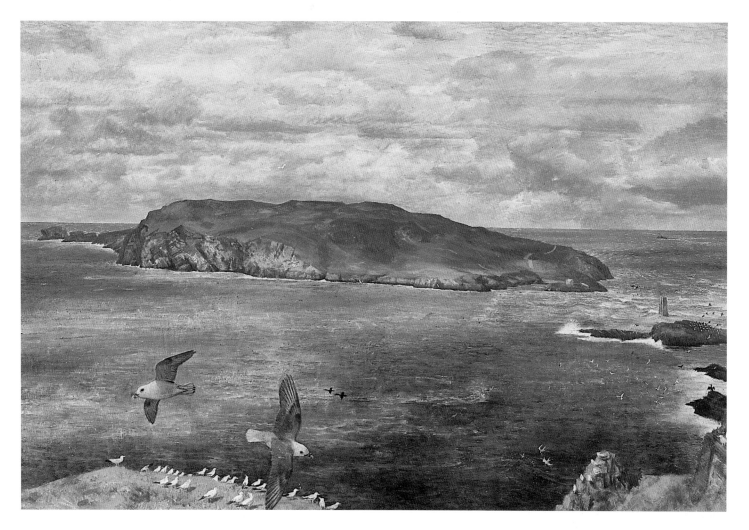

In the early 1960s Eurich was asked by Sheffield Hospitals Board to undertake two large murals in the foyer of their newly built Teaching Hospital. These murals, on opposite walls, were of Whitby and Chatsworth respectively (figs. 21 and 22), and show that his mastery of composition was as strong as ever. They were completed in 1968, the year of Eurich's retirement from Camberwell School of Art, and he accepted no further major commissions after this date.

Eurich spent nineteen years teaching part-time at Camberwell. Many of his students recall him with kindness, some for the contribution he made to their artistic development. Under its Principal William Johnstone (1938–47), who pursued an enlightened policy of appointing practising artists in the style of a French atelier, Camberwell had become one of the country's leading art schools. By the late 1940s Johnstone had attracted to his staff the leading members of the Euston Road School of artists, including William Coldstream, Victor Pasmore and Claude Rogers. Johnstone moved on in 1947, as did most of the group around Coldstream, but Camberwell continued to attract artists of high calibre under the new Principal, Leonard Daniels, who appointed Eurich in 1949. After he finished at Camberwell 1968, Eurich taught at the Royal Academy Schools between 1969 and 1971, making a further contribution to the development of the next generation of British artists.

Eurich's interest in education was also expressed through his participation in the Society for Education in Art, which held annual exhibitions either at the Tate or at the Whitechapel Galleries in London. Every year children were invited to vote for their favourite painting and, significantly, Eurich came out as the winner in most years.

In 1968 Eurich, for the first time in a decade, had a solo exhibition in London, with his new dealer, Arthur Tooth & Co. The selection of paintings for the exhibition presented a problem, because work over nearly twenty-five years was crammed into his studio. Thirty-four paintings were chosen.[67] The prices were not ambitious, at £700 for the largest painting and £80 for the smallest. In his introduction to the sale catalogue, Alistair Gordon wrote that the landscape in Eurich's paintings "reveals its history, its geography, its weather [and] the most important of all, the centuries of human toil that have made it".[68] In *Arts Review* Bruce Laughton wrote that Eurich's paintings were "timeless, scaleless [and] it is not surprising that the Museum of Modern Art, New York, own one of Eurich's paintings. They probably think he is a Surrealist. But he is an R.A. of extra sensitivity."[69]

The show was successful and was followed by two further exhibitions at Tooth's in 1970 and 1973. Among his new paintings was *Snow in Wharfedale* (fig. 23), a pleasing design in a naturalistic landscape. Michael Shepherd wrote of the 1970 exhibition in *Arts Review*:

It would be easy to describe these works as romantic – but there's more to it than that, a sense of the immanent and the imminent, which links Eurich

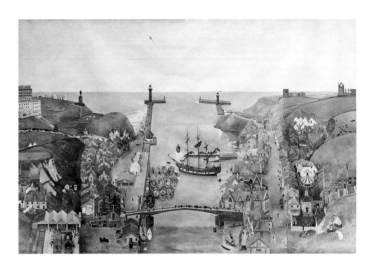

Figs. 21 and 22
Whitby, 1968; *Chatsworth*, 1968
Both acrylic on board, 305 × 427 cm
Sheffield Teaching Hospitals NHS Trust

with Chirico and the Italian metaphysical school on the one side and the "romantic" landscape school on the other. What is so remarkable about Eurich is that he has preserved, in a difficult time for painting, an exceptional artistic integrity which, instead of playing on surreal effects, puts 'strangeness' firmly within, and at the service of, natural reality.[70]

The review of the 1973 exhibition in *Arts Review* fell to Richard Walker. He, too, was captivated by a haunting quality in Eurich's paintings:

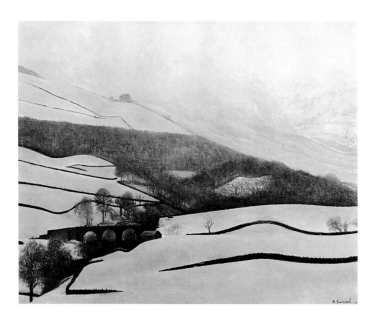

Fig. 23 *Snow in Wharfedale*, 1969
Oil on canvas, 41 x 51 cm
Private collection

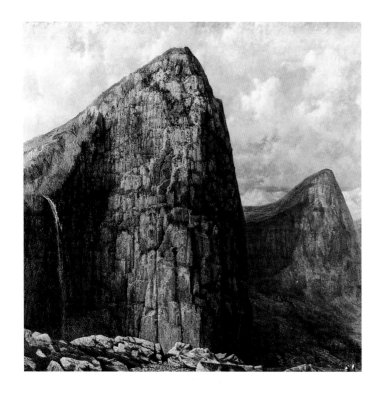

Fig. 24 *Mythen Alp*, 1971
Oil on board, 74 x 74 cm
Private collection

... many [of] which contain the sea ... and ships, have a clarity and clear, bare silence which immediately remind one of the treatment of similar scenes by war artists of both world wars. In this respect Eurich looks at the present through the glass of the past ... a silent loneliness sometimes almost Lowry-ish, though Eurich's human figures have a rounded, balloon-like Vorticist 'toyness' not at all like those of Lowry.[71]

One of the paintings from this exhibition that referred to an even older tradition of English art, that of J.R. Cozens, was *Mythen Alp* (1971; fig. 24), with its diminutive human figures in the context of a sublime rocky peak. Another, *The Road to Grassington* (1971; fig. 25), with its remarkable detail, retains an air of mystery that draws the viewer into the picture.

At last, after the extended trough from the mid 1940s until the late 1960s, Eurich was being taken seriously on his own terms by a new generation of critics. They had discovered a depth and strangeness in his painting that had eluded their predecessors in the 1950s and, far from condemning or ignoring it, they were intrigued.

When Tooth's closed in the mid 1970s, Eurich moved to The Fine Art Society. Peyton Skipwith of The Fine Art Society later recalled a conversation with Peter Cochrane of Tooth's in which Cochrane remarked, "He [Eurich] could probably have made more money elsewhere, but I knew he would be happier with you". Eurich had solo exhibitions with The Fine Art Society in 1977, 1983 and 1991, followed by a posthumous one in 1996.[72]

In the interval between his last exhibition with Tooth's and his first with The Fine Art Society, Eurich's son, the talented photographer Crispin Eurich, died in 1976 after a long illness. The effect of this untimely death on Eurich is apparent in his work in the years immediately afterwards. His six submissions to the Royal Academy Summer Exhibition in 1977 consisted of three still lifes and three pencil drawings, one with a wash, and even by 1978 two of his submissions were drawings; hitherto, every picture of his hung in the R.A. summer exhibition since 1937 had been an oil painting. After his son's death, Eurich seemed even less inclined to seek fame for himself or his art.[73]

Eurich's 1977 exhibition with The Fine Art Society attracted an enthusiastic review from Ormond Campbell in *Arts Review*, fully appreciative of Eurich's humorous juxtapositions and of his traditional landscapes.[74] A slightly surreal painting from this exhibition was *Workers Emerging* (1976; fig. 26), with the towering hull of a ship dominating the landscape of terraced houses while workers stride away from the shipyard, through skeins of washing strung across the street, at the end of their shift.

The appreciation for Eurich's art increased with each solo exhibition after 1968. Even as recognition returned, so his painting continued to develop. In the 1970s and 1980s a new style emerged, often characterized by a limited palette of colours and a diffuse silvery light that softened, even blurred, the edges of his figures, though a slight sense

of oddness or unreality persisted. It was this consistency of vision that gave coherence to all his work.

The positive reception accorded to his work after 1968 culminated in a substantial one-man retrospective exhibition at Bradford in 1979–80, curated by Caroline Krzesinska, that toured to The Fine Art Society in Glasgow and London before finishing in Southampton. This exhibition made a considerable impact, not least on John Russell Taylor, critic for *The Times*, who described it as "a major rediscovery operation". He went on to say: "Richard Eurich has been for many years one of those British painters who get neglected because they do not fit neatly into any obvious pigeonhole. He has never been extravagantly fashionable, and never dropped dramatically, totally from view."[75] He commented upon Eurich's ability "to handle enormous vistas with complete conviction … [better] than the work of any other modern British painter I can think of", and on his "flirtations with Surrealism in the mildly horrific scarecrow pictures of the late 1940s" (see fig. 27).[76] So taken was Russell Taylor by the exhibition that he took a further opportunity to review it in the spring when it reached The Fine Art Society in London:

I make no apology for writing again, at greater length, on the Richard Eurich retrospective … he seems to me one of the most astonishingly underestimated, or just unestimated, artists of his generation …. It is not so much the technique as the vision underlying the technique … there is always something stranger than first meets the eye. A sense that, just on the margins of the picture, something curious is going on, half-glimpsed, or that something everyday is rendered extraordinary by the angle from which he views it … [a] tendency to relish the bizarre at the heart of the ordinary.[77]

At the same time as this major exhibition toured the country, a smaller seventy-two work exhibition was on display at the Ash Barn Gallery in Petersfield. Peter Sanger, in *Arts Review*, noted that virtually all the paintings had been created in the last three years and commented that these recent works had "a superb feeling for atmosphere, that is also highly contemplative and inward-looking. The old virtuosity remains, but no longer does it have to be demonstrated …. Could it just be that his essentially traditional, figurative style contains more of substance than the work of many artists who have followed, or even led, fashion?"[78]

The success of the touring exhibition was consolidated in 1991 by a retrospective exhibition at the Imperial War Museum, dedicated to Eurich's work as an official War Artist, and this stimulated even wider comment. This exhibition was supported by Nicholas Usherwood's excellent catalogue.[79] Giles Auty reviewed the exhibition in *The Spectator* and made several salient points about the art establishment's neglect of artists such as Eurich:

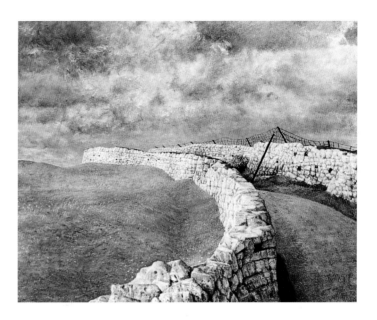

Fig. 25 *The Road to Grassington*, 1971
Oil on board, 41 x 51 cm
Private collection

I had thought him [Eurich] previously clever and idiosyncratic but had by no means suspected the grandeur of his pictorial imagination nor the real richness of his ability …. Indeed, those who set out to paint light and atmosphere, as Eurich does, take on painterly problems enough to last several lifetimes. By contrast, too few of today's artists engage in practices which look in the least inherently rewarding …. [Eurich,] like so many excellent British artists of the past 50 years, finds himself marginalised by the modernist mafia who have run our museums for the past 30 years or more.[80]

Auty also referred to the "crippling bias under which not just British but Western art has suffered during the past three decades", which had lauded artists who favoured modernism to the lasting detriment of painters such as Eurich who stood in the tradition of great British and European artists.

Frances Spalding, in *The Times Literary Supplement*, was less controversial in her review but equally forthcoming in her admiration for Eurich:

… in terms of drama and immediacy, very little Second World War art compared with that produced during the First. An exception, however, is the work of Richard Eurich …. Yet … he has never been associated with a particular movement or style, and he remains an elusive figure. His vision,

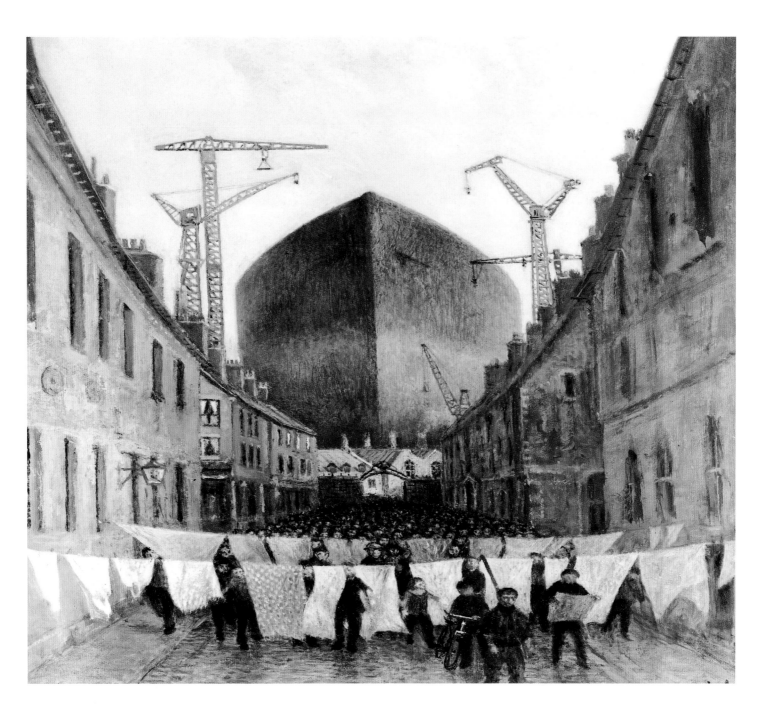

Fig. 26 *Workers Emerging*, 1976
Oil on board, 33 × 28 cm
Private collection

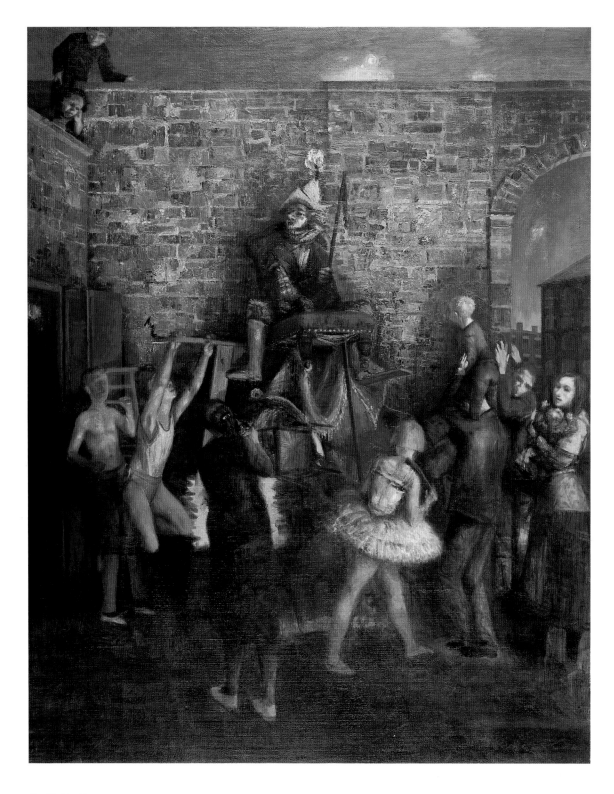

Fig. 27 *The Guy*
Oil on canvas, 127 x 101.5 cm
South London Gallery, London

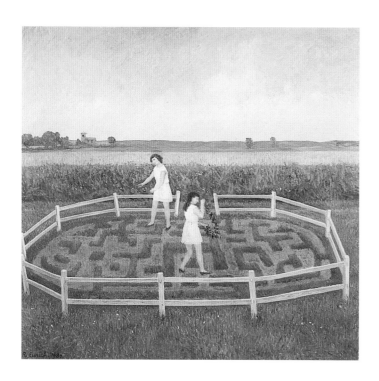

Fig. 28
The Maze, 1980
Oil on board, 56 x 58.5 cm
Southampton City Art Gallery

*innocent of theory, retains a childlike directness, which may explain why
each new showing of his work invites fresh recognition.*[81]

Eurich, although gravely ill in 1991, did visit the Imperial War Museum
exhibition, and remarked afterwards to a friend, "I was looked upon as a
back number by other painters, but I am glad I stuck to it. The critics
have all turned round. 'I told you so,' said they."[82]

Eurich died in June 1992 on the anniversary of D-Day. In his obituary
in *The Independent*, Peyton Skipwith referred to the irony that "Eurich
has continually been described by critics as an unjustly overlooked
artist", even though he had exhibited continuously at the Royal Academy
since the late 1930s. Skipwith referred to Eurich's retention of a childlike
sense of wonderment at the world, even into old age, that enabled him
"to create some of the best surrealistic imagery in English painting".[83] In
The Times the obituary writer regarded his later paintings as melancholy
and thought that their "poetic profundity" was "akin to that which the
eighteenth century found in ruins: the fleeting human comedy of
transience set against the eternity of change in the elements".[84]

In 1993 the Royal Academy hung six paintings by Eurich, selected by
his family, in the summer exhibition as a posthumous tribute to one of
the longest serving Academicians of the century. Richard Cork, reviewing
the exhibition, described Eurich as "a true poet of the English coastland"

and added that his "death is a real loss, for the most recent canvases are
among the best".[85] John McEwen, too, was moved to write that "Eurich
was probably the best of our official Second World War artists and
always a master of seascape".[86]

In 1994 a posthumous touring exhibition, *The Edge of All the Land*,
celebrated Eurich's long career as an artist. Ninety-three works were
brought together and the exhibition toured from Southampton to
Manchester, Bradford and Ipswich. Some critics were again taken by
surprise, with Robert Clark in *The Guardian* remarking that the
landscapes and figure compositions were "enough to make the show feel
like a notable discovery".[87] The most vehement review of the exhibition
was written by Jonathan Meades, who felt that Eurich, in the company of
other "hard-edged hallucinatory" realist painters, had become a casualty
of "abstraction's propagandists", and since these painters "paid no
oblations to the god of splodges and 'marks' … [their] work rarely
makes it out of the vaults". He claimed he experienced a dorsal shiver
before many of Eurich's paintings because "there is some item of
England's deep south that is so familiar yet so odd".[88]

Thus the market for Eurich's paintings began to pick up during the
last dozen years of his life, thanks largely to the successful 1979–80
exhibition. In 1984 recognition of his national contribution to British art
came when he was appointed OBE. and, on a more personal level, in
1989, when the University of Bradford awarded him the Honorary
Degree of Doctor of Letters. In 1988 John Sheeran, Deputy Keeper
(Fine Art) at the Bradford Art Galleries & Museums, commissioned a
portrait of him from his fellow Royal Academician, Leonard Rosoman, to
hang with portraits of other famous 'sons' of the city, including Delius, J.B.
Priestley and Sir William Rothenstein.

In a quieter form of recognition, Southampton City Art Gallery
bought *The Maze* (1980; fig. 28)) to mark Eurich's retirement, in 1982,
from thirty years as the Chairman and R.A. Representative of the F.W.
Smith Bequest Purchasing Committee. The Royal Academy, as has already
been mentioned, admitted six paintings by Eurich to their 1993 summer
exhibition as a mark of respect for his fifty years' service as an
Academician.

Although the final years of Eurich's career, particularly the exhibition
at the Imperial War Museum, restored his critical reputation, his place in
British art history remains undecided. He deserves to be still better
known because he stands in a direct line of succession from the leading
British artists of the eighteenth century, from the satire of Hogarth to
the elegance of Gainsborough and the sublime landscapes of Turner,
Constable, Crome, Blake and Palmer, and because of his very singular
vision of the extraordinary at the heart of the ordinary.

Bibliography

Anon., 'Obituary – Richard Eurich', *The Times* (9.6.92)

Auty, Giles, 'Marginalised masterworks', *The Spectator* (5.10.91)

Campbell, Ormond, 'Richard Eurich, R.A.', *Arts Review*, XXIX, no. 10 (May 1977)

Clark, Robert, 'Art. Richard Eurich', *The Guardian* (30.3.94)

Cork, Richard, 'Corn as high as an elephant's eye', *The Times* (4.6.93)

Gordon, Alistair, 'Introduction', *Richard Eurich, Paintings* (Arthur Tooth & Co., 1968)

Grimsditch, Herbert, 'Art Exhibitions of the Year', *Art Review, A Survey of British Art in All its Branches During the Year 1938* (London 1938)

Hassell, Christopher, *Sir Edward Marsh: Patron of the Arts* (London 1959)

Laughton, Bruce, 'Gallery Reviews', *Arts Review & Gallery Guide*, XX, no. 4 (2.3.68)

McEwen, John, 'The Arts: odd pearls amid the Purley wastes', *The Sunday Telegraph* (6.6.93)

Meades, Jonathan, 'A tradition of his own', *Modern Painters*, VII, no. 2 (Summer 1994)

Sanger, Peter, 'Richard Eurich, Ash Barn Gallery, Stroud', *Arts Review*, XXXII, no. 14 (July 1980)

Sawkins, Harold, 'Artists of Note: Richard Eurich', *The Artist*, XI, no. 6 (London, August 1936)

Shepherd, Michael, 'Eurich', *Arts Review* (10.10.70)

Skipwith, Peyton, 'Obituary – Richard Eurich', *The Independent* (10.6.92)

Spalding, Frances, 'Richard Eurich, From Dunkirk to D-Day, Imperial War Museum', *The Times Literary Supplement* (11.10.91)

Spalding, Frances, *Ravilious in Public, A Guide to Works by the Artist in Public Collections* (Norwich 2002)

Taylor, John Russell, 'Obstinate individuality is British strength', *The Times* (11.12.79)

Taylor, John Russell, 'The bizarre beneath the ordinary', *The Times* (18.3.80)

Usherwood, Nicholas, 'Richard Eurich by Nicholas Usherwood', *R.A., The Magazine for the Friends of the Royal Academy*, VII (Summer 1985)

Walker, Richard, 'Richard Eurich', *Arts Review*, XXV, no. 21 (October 1973)

Catalogues

Krzesinska, Caroline, *Richard Eurich, R.A.: A Retrospective Exhibition* (Bradford 1979)

Putt, Barbara, and Johnson, Lesley, *An Honest Patron: a Tribute to Sir Edward Marsh* (Liverpool, May – June 1976)

Usherwood, Nicholas, *Richard Eurich: From Dunkirk to D-Day* (London 1991)

Usherwood, Nicholas, *The Edge of All the Land. Richard Eurich 1903–1992* (Southampton 1994)

Archives

Imperial War Museum Archive, Lambeth Road
Tate Gallery Archive, Millbank, London

Notes

1 My thanks are extended to Caroline Toppin and Philippa Bambach, Richard Eurich's daughters, for their patience, forbearance and support through many long months of preparation for this essay and the exhibition it accompanies. My thanks go also to colleagues in the team that organized the exhibition: Professor Edward Chaney, Co-Curator; Graham Bartlett, Exhibition Project Manager; and Bridget Davis, Curator of the Millais Gallery. Finally, I am indebted to curators of previous major exhibitions of Richard Eurich's work, Caroline Krzesinska and Nicholas Usherwood, whose careful research and scholarship paved the way to this exhibition.

2 Bernard Dunstan, 'Some notes on Richard Eurich', *Richard Eurich* (Alresford Gallery, Spring 2000).

3 'Grossvater' Eurich (1839–1902) was a traveller for a Bradford firm of woollen manufacturers. He and his wife emigrated to England with their four small children. Richard Eurich, *As the Twig is Bent*, Tate Gallery Archive, Millbank, London (8813.1).

4 Harold Sawkins, 'Artists of Note: Richard Eurich', *The Artist*, XI, 6 (London, August 1936), p. 182.

5 Other examples of drawings on a musical theme include *The Great Viol* (1927), Bradford City Art Galleries, and *Fantazia* (1927), Usher Gallery, Lincoln. *The Muse* (1929), Whitworth Gallery, Manchester, resembles a *pietà* but the woman has a cello laid across her lap; it is illustrated in Caroline Krzesinska, *Richard Eurich, R.A.: A Retrospective Exhibition* (Bradford, 1979), p. 18.

6 Richard Eurich, *As the Twig is Bent*, chapters XI–XIV.

7 The prize was "Southey's *Life of Nelson*, superbly bound and with the school crest on the cover in gold". *Ibid.*, chapter XI.

8 Dr Eurich "had in his possession two miniatures, portraits of ancestors executed by a relation of ours on his side of the family in the middle of the last century ….When he was thirty years of age August Eurich decided to leave Germany for America with his wife and baby son. Unfortunately he died on the voyage and his wife earned her living by teaching music". *Ibid.*, chapter XIX.

9 Eurich loved church music and reverted to the Anglican tradition in later life. *Ibid.*, chapters XV and XVII.

10 *Ibid.*, chapter XIX.

11 *Ibid.*, chapter XX.

12 *Ibid.*, chapter XX.

13 The Drummond Foundation Grant was for the further education of Bradford Grammar School boys. *Ibid.*, chapter XXIV.

14 *Ibid.*, chapter XXV.

15 *Ibid.*, chapter XXIV.

16 *Ibid.*, chapter XXIV.

17 *Ibid.*, chapter XXIV.

18 *Ibid.*, chapter XX. Barbara Putt and Lesley Johnson, *An Honest Patron: a Tribute to Sir Edward Marsh* (Liverpool, May–June 1976), pp. 15 and 23. See also Christopher Hassall, *Sir Edward Marsh: Patron of the Arts* (London, 1959).

19 *The Broken Tree*, also known as *Landscape* (1926), is now in the collection of Darlington Art Gallery.

20 Putt and Johnson, *op. cit.*, pp. 23–24; *As the Twig is Bent*, chapter XXVIII.

21 *Ibid.*, chapter XXIX.

22 "Perhaps unconsciously I had in mind Dürer's engravings which I had admired so much and may have led Professor Tonks to suggest that I should take up engraving." *Ibid.*, chapter XXVI.

23 "Sir Michael Sadler purchased four drawings; Mr. Marsh also bought one, and gave it to the Contemporary Art Society" (Harold Sawkins, *op. cit.*, p. 184). *Study for Decoration*, the last, is now in the collection of Southampton City Art Gallery.

24 *As the Twig is Bent*, chapter XXIX.

25 Caroline Krzesinska, *op. cit.*, p. 10.

26 *As the Twig is Bent*, chapter XXVI.

27 "I hardly ever used a camera, and of course during the war it was out of the question." Eurich's undated covering note to six of Wadsworth's letters, Tate Gallery Archive (8813.113).

28 Nicholas Usherwood, 'Richard Eurich by Nicholas Usherwood', *R.A., The Magazine for the Friends of the Royal Academy*, VII (London, Summer 1985), p. 15. In his autobiography he says that "the feeling of organisation growing under my hand (one form leading to another as one brush stroke seemed to demand another and one colour another next to it) was the only guide I needed". *As the Twig is Bent*, chapter XXVIII. The murals at Royal Hallamshire Hospital, Sheffield, were commissioned in 1962 and completed in 1968. Both *Whitby* and *Chatsworth* are 305 × 427 cm (10 × 14 feet) in size; neither is presently on view.

29 These three paintings are: *Raid on Vaagso* (1942), Imperial War Museum; *Landing at Dieppe* (1942/43), Tate Britain; and *Raid on Bruneval Radio Location Station* (1943).

30 *As the Twig is Bent*, chapter XXIV.

31 *Ibid.*, chapters XIX and XXVI.

32 *Ibid.*, chapter XIX.

33 Imperial War Museum Archive, Lambeth Road, London, Eurich to E.M. O'Rourke Dickey (10.6.40). He does not specify whether it was the Elder or Younger Willem van de Velde that he admired more.

34 *As the Twig is Bent*, chapter XXIV. Tonks passed his remark to Eurich during one of the monthly Sketch Club exhibitions.

35 In 1928 Eurich "probably admired Gertler's paintings more than those of any other young man at the time". *As the Twig is Bent*, chapter XXVI.

36 A fashion in artistic 'migration' to the countryside had been established during the 1920s as a reaction in favour of 'rural values' and against the 'machine-age aesthetic', encouraged by good transport communications. Frances Spalding, *Ravilious in Public, A Guide to Works by the Artist in Public Collections* (Norwich, 2002), pp. x–xi.

37 Letter from Eurich to Sydney Schiff (10.5.44), Tate Gallery Archive, Millbank, London (8813.99). Schiff, a connoisseur and patron of contemporary British art, admired Eurich's work and they continued a long correspondence that only ended in October 1944 with Schiff's death.

38 *The 1936 International Exhibition of Paintings, October Fifteenth December Sixth*. Carnegie Institute, Pittsburgh. Personal correspondence with Heather Kapustynski, Carnegie Museum of Art, Pittsburgh (September 2002).

Robin Hood's Bay, exhibited at Pittsburgh in 1936, was bought by the Beaverbrook Art Gallery, New Brunswick, in which collection the painting remains. Personal correspondence with Laura Brandon, Curator of War Art, Canadian War Museum, Ottawa (August 2002). *Solent Fort* (fig. 10) was exhibited in Pittsburgh in 1937.

39 Herbert Grimsditch, 'Art Exhibitions of the Year', *Art Review, A Survey of British Art in All its Branches During the Year 1938* (London 1938), p. 34.

40 Personal letter from Dr Ted Gott, Senior Curator, National Gallery of Victoria (August 2002).

41 Correspondence with Sydney Schiff (10.10.39), Tate Gallery Archive (8813.30).

42 Correspondence with Edward Wadsworth (29.12.39), Tate Gallery Archive (8813.119).

43 Eurich's paternal grandfather became a naturalized subject of the British Crown, attracted to Yorkshire by the woollen trade.

44 Nicholas Usherwood, *Richard Eurich: From Dunkirk to D-Day* (London 1991), p. 13.

45 The initial sum promised was equivalent in 2002 to £1334, or £667 each, but was revised to the equivalent of £1894.28, or £947.14 for each painting, Bank of England Equivalent Contemporary Values of the Pound. Imperial War Museum Archive, Lambeth Road, London (memo from E.M. O'R. Dickey to Mr Trenaman, 24.6.40).

46 Letter from Eurich to Sydney Schiff (10.5.44), Tate Gallery Archive (8813.99).

47 Letter from Eurich to Sydney Schiff (27.10.43), Tate Gallery Archive (8813.85).

48 Letters from Eurich to Sydney Schiff (8.11.43 and 10.5.44), Tate Gallery Archive (8813.87 and 8813.99).

49 Quoted in Caroline Krzesinska, *op. cit.*, p. 12

50 The painting was purchased by the Smith Bequest Fund in 1949 and forms part of Southampton City Art Gallery's collection.

51 Letter from Eurich to Sydney Schiff (15.12.42), Tate Gallery Archive, Millbank, London (8813.62).

52 Letter from Eurich to Schiff (10.6.43), Tate Gallery Archive, Millbank, London (8813.71).

53 The correspondence between Eurich and Schiff on this subject (between 22.12.42 and 26.7.43) is held in the Tate Gallery Archive (8813.63, 73 and 74). *From Dachau* was exhibited at the Redfern Gallery between 8 April and 1 May 1943. My thanks are owed to Maggie Thornton, MD of the Redfern Gallery, for looking up the dates when this painting was exhibited.

54 Sydney Schiff to Eurich (1.7.43), Tate Gallery Archive (8813.73).

55 Richard Eurich to Sydney Schiff (27.7.43), Tate Gallery Archive (8813.75).

56 Richard Eurich, *op. cit.*, chapters XX and XXIV.

57 *Ibid.*, chapter XX.

58 Richard Eurich to Sydney Schiff (27.7.43), Tate Gallery Archive (8813.75).

59 Letter from Eurich to Sydney Schiff (19.6.40), Tate Gallery Archive (8813.36).

60 Tate Gallery Archive (8813.1). Eurich never wrote a sequel.

61 Letter from Eurich to Sydney Schiff (27.10.43), Tate Gallery Archive (8813.85).

62 Caroline Krzesinska, *op. cit.*, individual catalogue entries.

63 Letter from Nan Kivell to Eurich (16.10.58), Tate Gallery Archive (8813.22).

64 Letter from Sir John Rothenstein to Richard Eurich (4.1.51), Tate Gallery Archive (8813.25).

65 Postcard from Waugh to Eurich, Piers Court, Dursley, Gloucestershire, postmarked 17.2.53, Tate Gallery Archive (8813.152).

66 Nicholas Usherwood, *The Edge of All the Land: Richard Eurich 1903–1992* (Southampton 1994), p. 48. All three paintings are in private collections.

67 Nicholas Usherwood, *op. cit.* (1985), p. 13.

68 Alistair Gordon, 'Introduction', *Richard Eurich, Paintings* (Arthur Tooth & Co., 1968).

69 Bruce Laughton, 'Gallery Reviews', *Arts Review & Gallery Guide*, XX, 4 (2.3.68). The only painting by Eurich in M.O.M.A.'s collection is *The New Forest* (1939).

70 Michael Shepherd, 'Eurich', *Arts Review* (October 1970), p. 644.

71 Richard Walker, 'Richard Eurich', *Arts Review*, XXV, no. 21 (October 1973), p. 711.

72 Peyton Skipwith, 'Obituary – Richard Eurich', *The Independent* (10.6.92).

73 This perceptive observation was drawn to my attention by John and Imogen Sheeran of Sheeran Lock Ltd (private correspondence, September 2002).

74 Ormond Campbell, 'Richard Eurich, R.A.', *Arts Review*, XXIX, no. 10 (May 1977), p. 322.

75 John Russell Taylor, 'Obstinate individuality is British strength', *The Times* (11.12.79). This review referred to the exhibition while it was in Bradford from 25 November 1979 to 20 January 1980. Other scarecrow pictures besides *The Guy* (fig. 27) include *Battle of the Boggarts* (1948), private collection, and *Men of Straw* (1957), Nottingham Castle Museum and Art Gallery.

76 John Russell Taylor, *ibid.*

77 John Russell Taylor, 'The bizarre beneath the ordinary', *The Times* (18.3.80). The exhibition remained at The Fine Art Society, London. from 10 March to 11 April 1980.

78 Peter Sanger, 'Richard Eurich, Ash Barn Gallery, Stroud', *Arts Review*, XXXII, no. 14 (July 1980), p. 310.

79 Nicholas Usherwood, *Richard Eurich: From Dunkirk to D-Day* (London 1991).

80 Giles Auty, 'Marginalised masterworks', *The Spectator* (5.10.91), p. 39.

81 Frances Spalding, 'Richard Eurich, From Dunkirk to D-Day, Imperial War Museum', *The Times Literary Supplement* (11.10.91).

82 Nicholas Usherwood, *op. cit.* (1991).

83 Peyton Skipwith, 'Obituary – Richard Eurich', *The Independent* (10.6.92).

84 Anon, 'Obituary – Richard Eurich', *The Times* (9.6.92).

85 Richard Cork, 'Corn as high as an elephant's eye', *The Times* (4.6.93).

86 John McEwen, 'The Arts: Odd pearls amid the Purley wastes', *The Sunday Telegraph* (6.6.93).

87 Robert Clark, 'Art. Richard Eurich', *The Guardian* (30.3.94).

88 Jonathan Meades, 'A tradition of his own', *Modern Painters*, VII, no. 2 (Summer 1994), pp. 44–45.

Plotting Eurich's Co-ordinates on the Map of Twentieth-Century Art

ALAN POWERS

If someone asked, as they justifiably might, 'What kind of painter is Richard Eurich?', what would be the correct answer? The comprehensive study of twentieth-century British painting remains to be written, and in the absence of such a work it is hard to consider Eurich other than as an isolated or eccentric figure, but this would be wrong on several counts. A visit to Tate Britain is, however, unlikely to dispel this impression, even though the collection holds a number of pictures that would help to position Eurich. While some of these have been hung in thematic displays in recent years, the rest of the material needed for the study exists in provincial public collections or in private hands. The criteria adopted at the Tate may not necessarily be wrong, but they are the result of a particular process of selection, influenced by the most cogent critical voices of the century, from Roger Fry, Herbert Read and R.H. Wilenski through to Charles Harrison in the 1980s. For them, the future of art was presumed to lie with the development of formal innovation, which could be observed to follow a progressive evolutionary path. To deny this was to risk condemnation for conservatism and provincialism, regardless of the fact that dissenters from this 'progressive' view of art were not unique to England but existed in every other country during the same period. The situation has remained much the same for a hundred years, partly because those who held differing views were never able to project them with sufficient persuasiveness to move in from the margins.

Though he wrote a series of lives of individual *Modern English Painters*, John Rothenstein, even as Director of the Tate from 1938 to 1964, failed to write the synoptic narrative of the period, as he was uniquely qualified to do. In the 1970s and 1980s, Peter Fuller raged against the shallowness of the official establishment view, but never had the time needed for establishing his oppositional view on a basis of detailed knowledge. It is unclear whether Fuller's work has had a lasting effect. While *The Modernity of English Art 1914–30* by David Peters Corbett, published in 1997, seeks to broaden the canon of this difficult and elusive period, the author takes it as axiomatic that the value of art depends on its direct relationship to 'modernity', defined as urban and mechanistic.

Most public displays reflect this established vision of British painting, posited on the development of formal qualities leading towards modernism and abstraction. The subject-matter of a painting may be acknowledged but is seldom taken seriously – compared, say, to the narrative content of Victorian paintings. The main challenge to the canon has consisted in the admission of the existence of a plurality of voices, and perhaps in linking this diversity to a concept of Englishness, or possibly Britishness, since the painters of Scotland, Ireland and Wales have national characteristics of their own. In the broad diffusion of ideas relating to Post-Modernism, pluralism is an effective tactic. To achieve a 'both … and' version of history, rather than an 'either … or' version, is still difficult, since most education is based on dialectic, requiring a choice

to be made. One can imagine, however, a horizontal network of critical positions instead of a pre-ordained hierarchy. This would be a different and liberating form of mapping, appropriate to the diversity of readings that are increasingly becoming accepted even within the work of some of the major figures within the modernist canon, such as Henry Moore and Ben Nicholson, which contains more narrative and associative elements than earlier commentators in the formalist school were ready to admit. After so many years in which they have been separated, the critical discourse still has difficulty in reconciling the claims of form and content that to an artist may be an obvious unity.

The essay that follows discusses Eurich primarily in terms of the content of his pictures, and relates him to other artists who worked with very specific, often narrative, imagery. In doing so it proposes other ways of reading his paintings, of a kind that are applied without question to the work of earlier centuries, but for no good reason are considered inappropriate for twentieth-century work. Eurich's choice of content came before his desire to become a painter and drove his art. For example, the sea was an instinctive love on his part. He wrote later about his first experience of seeing the sea, from a train between Whitby and Sandsend, as "the climax of the feeling that the chains of the war and school had been thrown off. That line of cargo boats on the horizon … filled me with an inner joy that is difficult to explain."[1] Before going to the Slade School of Art, he discovered the work of Turner at Farnley Hall in Wharfedale; much of this work had been produced in the house itself for Walter Fawkes, which added to its immediacy. It is therefore not difficult to draw connections between Turner and Eurich's love of painting the sea and ships. Although the sea and boats are a recurrent theme in English art, Eurich's words go beyond a mere liking towards something else – perhaps the same excitement that Edward Ardizzone captured in his stories of Little Tim, who continually fulfils every boy's fantasy of running away to sea and living as an adult in a completely masculine society, in the otherness of the ocean. It could be the same feeling that David Jones put into his pictures of ships seen from the coast, and later built into the great cosmic architecture of his poem The Anathemata (1952). It is more magical than the feeling of Edward Wadsworth's ships, but not far removed from Wyndham Lewis's identification of the best qualities of Englishness with seafaring in the opening manifesto section of Blast, 1914: "BLESS ENGLAND! BLESS ENGLAND FOR ITS SHIPS which switchback on Blue, Green and Red SEAS all around the PINK EARTH-BALL."[2]

In the same text, Wyndham Lewis called the ocean a "vast planetary abstraction", and Eurich spoke of it in terms that reveal the analytical underpinning beneath his depiction of sea water. On holidays with cousins at Weymouth, he went to Chesil Beach to paint, and studied "the structure of water, not just the sea as a blue background with landscape or harbours as the main feature. When out sailing I never tired of watching the formation of the water breaking against the sides of the boats, and the wake in particular with all its diverse currents interlaced with broken water, forming wonderful patterns expanding and contracting as the distribution of weight shifted endlessly."[3] This alone, however, would not have been enough to sustain Eurich's marine paintings. It is his quality of imagination that enables him to rise above the hack painters of the genre. When seeking work as a War artist, he wrote of his hope that "the traditional sea painting of Van de Velde and Turner should be carried on to enrich our heritage".[4] We know at least that Turner's images of the sea and ships were also allegories and depictions of the human condition. The artist's verbal descriptions do not necessarily help us to appreciate them better, but fortunately the paintings achieve everything necessary on their own. One could imagine a Turner-struck painter of Eurich's generation absorbing the over-dramatized imagery of Frank Brangwyn, but again he showed himself true to his own inner vision: his ships do not loom and threaten, but, like those seen from the train, are usually distant and poised somewhere out of reach.

It is strange that, apart from his work for Shell, Eurich was never commissioned to make illustrations, as. for example, were his contemporaries Ardizzone, Edward Bawden, Eric Ravilious and Rex Whistler, some of whom ceased to develop as painters because their attention was diverted into this activity. Was this the result of opportunities refused by Eurich, or simply never offered? Narrative and subject painting come close to illustration, a word that many painters shun for its negative connotations. 'Mere' illustration implies a loss of the depth that painters properly seek, but it is artificial to separate it off from painting when considering subject-matter in painting as a whole. One of the aspects of twentieth-century English painting seldom discussed is its closeness to Victorian art, which, after all, formed a substantial part of the diet on which Eurich's generation were raised. The reappraisal of the Pre-Raphaelites, not merely among critics but among art students, goes back to before the First World War, when Dora Carrington wrote to John Nash that she wanted to paint a picture like Holman Hunt's The Hireling Shepherd.[5] With the impact of formalist criticism in the 1920s, the mid nineteenth century had the lure of forbidden fruit. It also had scholarly defenders, like the writer Forrest Reid, whose classic study, Illustrators of the Eighteen Sixties, was published in 1928. "Illustration has come to be regarded as a dubious mixture of art and something that is not art", Reid wrote, but challenged this view by claiming that "most of the masterpieces of the world are illustrations".[6] Even the works of J. McNeill Whistler, to whom he attributed the origin of much of the feeling against illustration, were claimed by Reid to exemplify its main characteristics. This position was also developed, again in 1928, by the artist James Guthrie in an article, 'Tendencies in Illustration', in Artwork magazine, claiming that "interpretive illustration … may well be a most serious kind of art in spite of the fact that the images are suggested by reading. These images when set

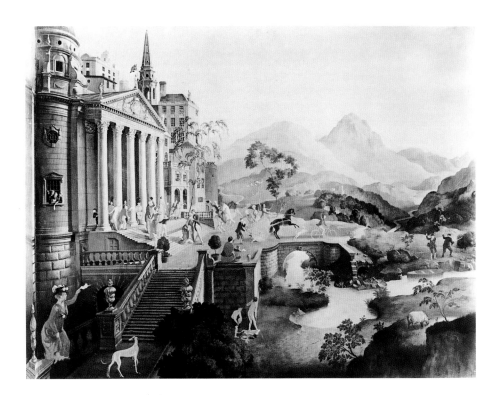

Fig. 29 Rex Whistler
(1904–1944)
City of Epicuranea, 1926
Flatted oil
Restaurant B, Tate Gallery
Tate Britain

alongside those of the text will, if adequate, be infinitely more suggestive and satisfying than those of the ordinary kind which merely confirm or decorate a narrative."[7] Guthrie cited in support of his views a recent article by *The Times* art critic, Charles Marriott, on "the persistent vitality of the Pre-Raphaelite spirit in painting".

The most prominent artist, then as now, for whom this claim would have been made was Stanley Spencer, whose painting *The Resurrection, Cookham* was exhibited at the Goupil Gallery early in 1927, before being presented to the Tate in the same year by Lord Duveen. This was during Eurich's final year at the Slade, where Spencer himself had been a student. *The Times* declared it "the most important picture painted by an English artist in the present century".[8] Today, we tend to think of Spencer as an isolated eccentric genius, which he was, but the sources of his work and his aspiration to make a modern equivalent to the great works of the Renaissance were shared by many others in his own generation and those following after. Although the training at the Slade was primarily focused on life drawing, the 'Summer Composition Prize' was an important exercise going back to the 1870s, which, while attracting a wide range of different types of entry over the years, gave continuity to the idea of the imaginative grouping of figures, even though the art world had little commercial use for it. Spencer's own *Nativity*, the winner in 1912, hung and still hangs at the Slade as an exemplar, and was the first in a line of intensely felt, dreamlike paintings to come from the School, taking the place of the genre-like subjects that had

dominated the competition for several years before. It was probably no coincidence that Herbert Horne published his monograph on Botticelli in 1908 and that 1913 saw the publication of Laurence Binyon's study, *The Art of Botticelli*, which sought to discover "what the art of a Florentine of the Quattrocento means for us today".[9] Spencer had in several ways already answered the question, and continued to provide additional depth to his responses. Eurich's first exhibited works in 1929, following in Spencer's footsteps at the Goupil Gallery, continue the same discussion with their tight pencil renderings of symbolic figures, such as *The Muse* (1929; Manchester City Art Gallery). It should also be recalled that Eurich's time as a Slade student coincided with the execution in 1926 of the murals (fig. 29) at the Tate Gallery Refreshment Room by Rex Whistler, a fellow student two years his junior, whose influence seems to reappear in Eurich's work much later on.

In Eurich's own account of his life, his brief meeting with Christopher Wood at his Goupil exhibition was important in opening new directions to him. The advice given to Eurich by Rex Nan Kivell, Wood's dealer at the Redfern Gallery, to go to the coast and paint, might have seemed a very different point of departure compared to these early drawings, and was undoubtedly liberating. Eurich's handling of paint became for a time similar to Wood's slightly naive folk-art fullness of colour and unlike his later style. Wood's interest in symbolism and magic may have been more important for Eurich in his later development. It relates to the renewed interest in the Renaissance in the interwar period that can itself be

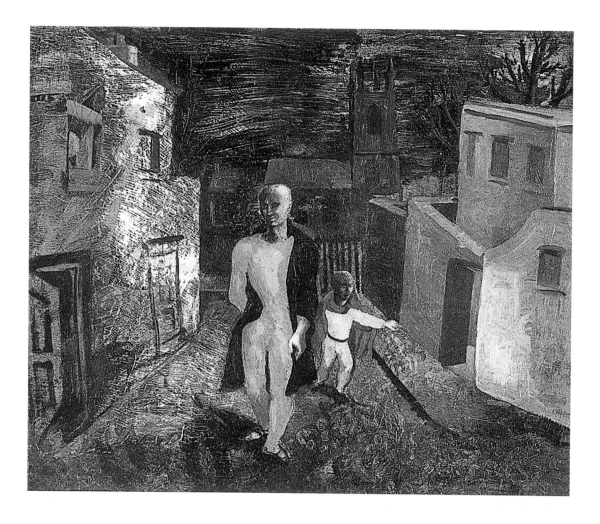

Fig. 30 Christopher Wood
(1901–1930)
The Yellow Man, 1930
Oil on canvas, 50.8 × 61 cm
The late Sir Brinsley Ford

linked to some of the interests of the Pre-Raphaelites, via the Symbolists of the 1890s. If the legacy of Bernard Berenson's writing on Renaissance painters appears to have served principally to bolster the formalist modernism of the twentieth century, there were other aspects of Renaissance art that led in quite different directions. Rather than sharing the conventional view of the Renaissance as part of the great ascent to modernism, Henryk Skolimowski, a writer of our own time, has described it as "the civilisation that did not make it", [10] meaning that the mechanistic-materialist world view of the seventeenth century closed off the belief in magic still prevalent in the Renaissance and de-sacralized the world. This alternative view of the period informs the work of scholars such as Edgar Wind, Rudolf Wittkower, Erwin Panofsky and Frances Yates, who emphasized the ways in which the Renaissance was distinct from the dominant scientific rationalism that has lasted into our own time. Through these scholars, and with some additional help from C.G. Jung, many have been able to approach narrative and subject pictures not just with a code-book of mythology or legend, but with a

deeper awareness that magic and alchemy once offered truths about the world and our place in it that conventional science cannot recognize. Even more, they offer them in terms that can create a visual *frisson* even for spectators who are not sure what is happening. Some writers on these themes are willing to accept that archetypal images can surface spontaneously in the minds of artists and their public, and do not need to be linked to specific and known sources of inspiration.

These observations have relevance to Wood's art, especially to the more mysterious paintings of the end of his life, for example those involving the display of tarot cards, such as *Calvary at Dounarnenez* (1930). There is no evidence that Wood had a coherent iconography for such works, but equally the content was not random either. The viewer's willingness to absorb it subliminally, as one aspect of a painting offering other more direct pleasures, mirrors the way that such themes may have arisen spontaneously for the artist. Wood's painting *The Yellow Man* (1930; fig. 30), showing a yellow-clad saltimbanque and his child ascending a street in a small town by night, is specially interesting in this

Fig. 31 James Fitton (1899–1982)
Canal Bridge, 1933
Oil on board, 69.1 × 76.8 cm
Private collection

respect, as it has the same mood as several of Eurich's paintings of slightly hallucinatory events taking place in everyday surroundings.[11] A similar mood was struck in the winner of the Slade Summer Composition of 1926, *A Day in your Life* by Helen Lessore, showing a realistic but still dream-like urban 'event'.[12]

In Eurich's art of the mid 1930s there is less evidence of this kind of strangeness. Works such as *From the Old Walls, Lyme Regis* (1932), *The Blue Barge* (1934) and *Collier Brig, Falmouth* (1936; all Manchester City Art Gallery) develop an intensity that owes more to careful observation (parallel to the work of Eric Ravilious, perhaps) than to a deliberate surrealist intervention in the imagery. The influence of Wood's more magical pictures comes later in Eurich's career, with what Nicholas Usherwood has described as "dream-like fantasy and recollections of his childhood".[13] In the 1930s Eurich's near contemporary James Fitton was developing such a style of work, seen in *Canal Bridge* (fig. 31) and *Entering Harbour*, both of 1933. Carel Weight pushed further the sense of strangeness in everyday life in early paintings such as *Allegro Strepitoso*, showing an escaped lion in the zoo, and *Symphonie Tragique*, both of 1932. Eurich and Fitton became Royal Academicians in 1953 and 1954 respectively and Weight was an Associate of the Royal Academy from 1955. To put their three careers side by side in an exhibition would be an interesting exercise, dispelling some of the implication of isolation that attaches to each of them. A Scottish painter with comparable ability to re-enchant the world, whose work has been the subject of a recent revival of interest, is John Maxwell. In a broad sense, all were romantic artists, interested in the correspondence between perception of the outer world and the inner state of mind or soul. The terms 'Romanticism' and, even more, 'Neo-Romanticism' acquired a specific meaning in the 1940s, associated with the artists John Piper, Graham Sutherland and Henry Moore, together with a number of younger figures, but the group outlined above tended to achieve their emotional effects while remaining closer to an observed scene.

Eurich is not always a narrative painter in the sense that his pictures have figures engaged in activities that tell a story, as Carel Weight's invariably do. Perhaps a better word for many of them would be 'emblematic', a word brought back into currency by the Warburgian scholars mentioned above. His early portraits, *Self-portrait: The Green Shirt* (1932; cat. 17) and *Man in a Bowler Hat* (1936), include backgrounds similar to those that a slightly naive eighteenth-century painter might naturally have included to provide information about the sitter's occupation. A painting such as *December: Work Suspended* (1940; cat. 25) marks a further stage of development. It shows a port under snow where a fine three-masted ship lies alongside a wharf, amidst small details of human activity. There is no 'story' as such, but the important thing we need to know is that the scene is an imagined one. It evokes the sense of unease during the 'phoney war' by means that are powerful because they are neither descriptive in a documentary sense nor allegorical. They just are. Although similar in some respects to the Falmouth picture of four years earlier, and superficially a work of topography, it is one of the signals of Eurich's future development.

Alan Ross wrote of the artist's war work that "Eurich saw it as his task to record events as accurately as possible, not by symbols or sign language, but by the precise rendering of detail".[14] Ross went on to write that Eurich sacrificed his looser style of brushwork and painted "as if his pictures were going to be scrutinised for their intelligence value".[15] Eurich took his recording rôle as seriously as any other artist on the scheme, but also discovered how to infuse and transform documentary content with emotional charge. That he achieved this by turning still further away from modernism or expressionism may seem perverse or paradoxical, but, in opposition to Ross's view, we may ask whether it may not reflect a deepening of Eurich's romanticism, achieved through the human content of the events portrayed. Even if actual figures are rarely depicted, the knowledge of the actual event taking place, even at a small scale in the distant part of a picture, creates a tension not previously present. With his painting *Survivors from a Torpedoed Ship* (1942; cat. 29), a reconstruction of a real feat of stoic heroism, Eurich found that he had achieved this aim so well that it was officially withdrawn from public exhibition in 1943 as it was feared it would damage morale. Eurich wrote to his friend, the writer and collector Sidney Schiff, that he had painted it at a relatively small scale "so that anyone really sympathetic would go and look at it and sympathise but a subject of that sort done large would be just vulgar and unbearable".[16] Sensitivity of this kind and a refusal to over-emotionalize could be attributed to Eurich's Quaker background.

Eurich had already developed a documentary eye before the War and, by luck, he had spent a summer holiday in 1939 at Dunkirk, so that he was able to paint his scene of the evacuations twelve months later, *Dunkirk Beaches* (1940, Imperial War Museum), with great accuracy. This was one of his first uses of a wide panorama and a high viewpoint for a documentary reconstruction, techniques which had been explored in earlier centuries but which many twentieth-century war artists preferred to abandon in favour of the eye-witness view of the observer on the ground. In fact, as Nicholas Usherwood notes, with the support of a letter written by Eurich, many of his paintings that appear documentary, such as *Preparations for D-Day* (1944, Imperial War Museum), are the creation of his imagination. He was supported in this direction by his friend the painter Edward Wadsworth, who wrote to him in 1941: "In 30 or so years people won't be interested in what this war looked like: on the other hand, in even 100 years, if it survives, people will still be interested in Uccello's battle picture – and you're not going to tell me that any battle ever looked like that …".[17] Eurich's compositions are often effective because he avoids predictable arrangements of diagonals constructed to lead the eye into the picture space, contrasts of scale between foreground and background, and so on, which other painters

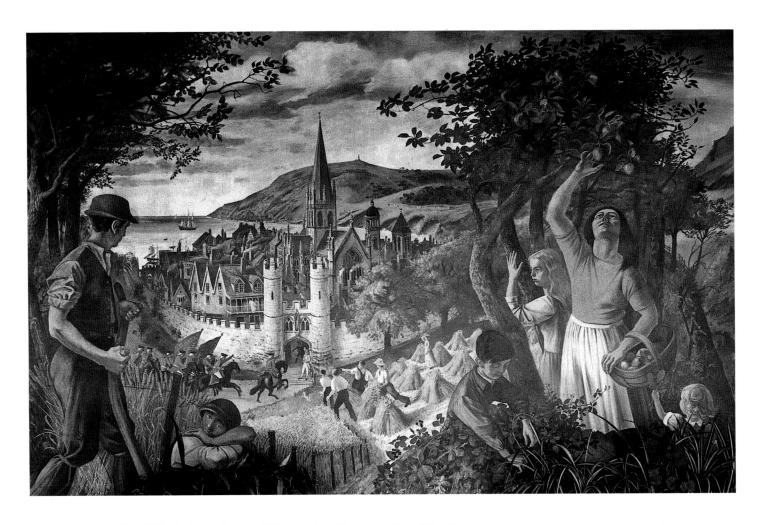

Fig 32 Alan Sorrell (1904–1974), *The Seasons: Summer*, 1953, oil on plaster, Myton Junior School, Warwick

reproduced almost without thinking. Perhaps the attribute he shares with Eric Ravilious as a war artist is an ability to surprise you with a fresh angle, without ever letting the composition go flat. Eurich painted *The Great Convoy to North Africa* (1942) as a panorama of shipping. Where another artist might have left it at that, give or take the addition of some dramatic clouds, Eurich places in the dead centre a pair of hands raising binoculars to enlarge a detail of the warships guarding the convoy, rather as Ravilious in one of his submarine lithographs shows the commander looking through the periscope, with a vignette beside him of what he is seeing. The cross-section through the water in *The Midget Submarine Attack on the Tirpitz, 22 September 1943* (1944; cat. 30), while similar in pictorial technique to what might have been seen in an illustrated magazine of the period, manages to make such reportage into art through an exact attention to scale and detail.

In his anxiety to make a separation between conventional formal means and expressive ends, Ross misses the subtlety of Eurich's wartime

set pieces. They are credible enough to elicit the response 'so that was what it looked like', but this impression is not the product of a photographic representation, more the reflection of the artist's inner eye. Some of the wartime works by Eurich, such as *Night Raid on Portsmouth Docks* (1941, Tate Britain), as well as some of his post-war compositions, prompt comparisons with his contemporary Alan Sorrell, a Rome Scholar in 1928. Sorrell's gift for peopling imagined or reconstructed buildings seen from a high viewpoint was beneficially exploited by what was formerly the Ministry of Works in illustrations of its castles and other historic sites. Sorrell's purely imaginary compositions are less well known, but he was drawn to symbolic representations of modern life, often, like Eurich's *Straw Men* (1957), implying criticism of the *status quo*. Richard Sorrell has continued working in a way recognizably similar to that of his father, demonstrating that Eurich's peopling of wide urban panoramas with faintly unsettling activities, for example *Mischief Night* (1975), are not alone or without successors. Alan Sorrell painted murals

Fig. 33 David Inshaw (1943–)
The Orchard, 1977
Oil on canvas, 120 × 180 cm
Private collection

at Myton School in Warwick in the early 1950s (fig. 32) that demonstrate his debt to Bruegel and apply compositional strategies also employed by Eurich, who painted murals for Sheffield Teaching Hospital in 1963, commissioned through the Edwin Austin Abbey Memorial Trust. Eurich recorded that he was particularly pleased when a music critic compared him to Ralph Vaughan Williams because "I did not get into ruts or develop along lines my friends had predicted".[18]

If Eurich is difficult to 'place' in the inter-war period, his position in the post-war years may look even more marginal. Again, it depends on the criteria used to construct a view of the 'centre'. Figurative painting was never obsolete or extinct in this period, and in some ways enjoyed a higher status than in the 1930s, but in a recent survey of this under-explored area Eurich receives only a passing mention.[19] It was in the later 1940s and the 1950s that Eurich developed the genre of detailed topographical scenes, nearly always of coastal locations, drawn in whole or part from imagination, that he had initiated immediately before the War. These build up into a series of seaports, perhaps a homage to Turner in the same way that Turner paid homage to Claude. *The Queen of the Sea, 1911* (1954), a childhood memory of Whitby, has as much Rex Whistler to it as it has North Yorkshire. The meeting of sea and land

is Eurich's theme in works that play across a variety of moods and locations from the *Fête de Sainte Maries-de-la-Mer* (1948), a composition unusually thronged with figures, to *The White Ship*, probably of the 1940s, which is closer to the pre-war paintings in being unpeopled except by magnificent vessels. During these years Felix Kelly painted scenes with elegant paddle steamers in harbour, not unlike some of Eurich's, but after a promising start began to repeat himself formulaically. From this period, too, come Eurich's grand views of cities, like *York Festival Triptych* (1954–55) and *Rouen Resurgent* (1956; see fig. 19, p. 23). The former is an idealization of the city, altering its topography to achieve a composite essence. Now, it cannot help but make us think of the visual intrusions and damage done even in this 'heritage' city, while the Rouen painting was a celebration of the reconstruction of the city in 'period' style. The *York* painting is a tableau not unlike Rex Whistler's *City of Epicuranea* (fig. 29), from which his fantasy travelling party set out and return in the far right corner of the Tate Refreshment Room, although here there are dust carts and smoking factory chimneys as well as old-fashioned shops and a pageant of the Mystery Plays in the central position. With aspects of dream about it, this could well be construed as a symbolic cityscape, leading up to the Minster crowning the skyline. *Scenes of my Childhood*

Fig. 34 Letitia Yhap (1941–)
Pig-a-Back, 1981–83
Oil on board, 96.5 x 152.4 cm
Private collection

Fig. 35 Ian Hamilton Finlay (1925–)
Homage to Jonathan Williams, 1972
Ink on paper
Private collection

(1957), set in a West Riding valley, appears also to be an attempt to capture, in terms recognizable to his audience, the feel of a good city or town, such as was already breaking down under the pressures of modernity; or compare again his Post Office commission of *Richmond, Yorkshire* (cat. 37). These paintings have more of a direct message now and in the future as visualizations of unrecognized paradises.

Eurich's later work, from the mid 1960s onwards, deserves a more extended discussion than it can receive here. While in some respects still outside the centre of the London art world, Eurich was perhaps ahead of it. His work began to change, involving larger figures, often nudes on beaches or in rooms, painted with a clarity and simplicity that was being sought by other artists who had less experience in figuration and less support in working for it. Many of Eurich's later paintings would look comfortable in the company of the Brotherhood of Ruralists, formed in 1975 by Peter Blake, Jann Haworth, Graham Ovenden, David Inshaw and other artists. The themes of narrative and romanticism were well-timed for a weary Britain, and they responded to a romanticism that the counter-culture of the 1960s had helped to bring to the surface. Stanley Spencer's reputation began to grow, and David Inshaw was the owner of a fine example of his work. Eurich's *Burning Tree at Studley Royal* (1977; see also cat. 46) is one of his strangest paintings of any period, based on the projection of inner vision into landscape, with connotations of an

Old Testament event such as the Burning Bush. 1977 was the high year of ruralism, so perhaps there is a connection, for the openness of the landscape looks similar to several of Inshaw's works (fig. 33).

Yet this does not finish the possibilities of placing Eurich in diverse contexts. His paintings of bathers on the seashore, such as *Robing Figures on a Rainy Day* (1969) or *The Black Tent* (cat. 57), could be related to the Hastings beach paintings of Letitia Yhap (fig. 34), while his still more visionary *Gathering of the Waters* (1970), where a nude male figure appears to be sliding head-first down a 'solid' wall of water while a female nude in profile steadies herself on the shore, perhaps to catch him, all under a harvest moon, has something of Jeffrey Camp's use of acrobatic and sexual seaside figures. These paintings depict the seascapes around the Solent where Eurich had chosen to live in the 1930s, and where he was fascinated by the continuous flare rising up from the chimney of the Fawley Oil Refinery; see *The Seven Sisters* (1960; cat. 38). It is odd, and perhaps touching, that Eurich apparently came to the subject of the female nude so late in his career. His *baigneuses*, as seen in *Figure and Planes* (1977), have Rodinesque figures. One could weave a number of 'literary' themes around them, but to no great purpose. Not many artists would have seen the value of putting two low-flying fighter-jets, a common interruption of British beach scenes in the Cold War years now slipping out of memory, into an otherwise idyllic painting such

as this. Perhaps the opposition of the idealized quasi-classical figure and the modern instruments of war could be reconciled by analogies to the work of Ian Hamilton Finlay (fig. 35). He and Eurich share, after all, a sense that the sea and boats are a lifetime's theme, so rich in meaning as never to dry up.

Notes

1 Eurich, quoted in Caroline Krzesinska, Introduction to *Richard Eurich, RA. A Retrospective Exhibition* (Bradford 1979), p. 7.

2 Wyndham Lewis, *Blast* (London 1914), p. 22.

3 Quoted in Krzesinska, *op. cit.*, p. 7.

4 Quoted in Meirion and Susie Harries, *The War Artists, British Official War Art of the Twentieth Century,* (Imperial War Museum and Tate Gallery, London 1983), p. 218.

5 "Oh isn't 'The Hireling Shepherd' amazing! I really think they got there. Wouldn't you like to do a real picture like that?" Dora Carrington to John Nash, 2 August 1914, John Nash papers, Tate Gallery Archive, Millbank.

6 Forrest Reid, *Illustrators of the Eighteen Sixties* (London 1928), p. 2.

7 James Guthrie, 'Tendencies in Illustration', *Artwork*, no. 12, January–March 1928, pp. 230 and 237.

8 *The Times*, 28 February 1927.

9 Laurence Binyon, *The Art of Botticelli, An essay in pictorial criticism* (London 1913), p. vii.

10 H. Skolimowski, *The Participatory Mind* (London 1994).

11 *The Yellow Man* was bought from Wood's Paris studio in 1930 by Lucy Wertheim, and exhibited in London soon afterwards. In 1938 it was included in the Wood retrospective at the Redfern, having recently been acquired by Brinsley Ford. Information courtesy of Richard Ingleby.

12 Illustrated in James Hyman, *The Battle for Realism* (New Haven and London 2001), p. 120, where it is compared to work by Eurich.

13 Nicholas Usherwood, 'Introduction' in *The Edge of All the Land: Richard Eurich 1903–1992* (Southampton City Art Gallery, 1994), p. 8.

14 Alan Ross, *The Colours of War* (London 1983), p. 96.

15 *Ibid.*, p. 99.

16 Eurich to Schiff, 3 May 1942, quoted in Usherwood, *op. cit.*, p. 44.

17 Edward Wadsworth to Richard Eurich, 10 April 1941, quoted in Barbara Wadsworth, *Edward Wadsworth, A painter's life* (Wilton 1989), p. 289.

18 Quoted in Usherwood, *op. cit.*, p. 14.

Appletreewick: A Daughter's Memoir of a Hampshire House

CAROLINE TOPPIN

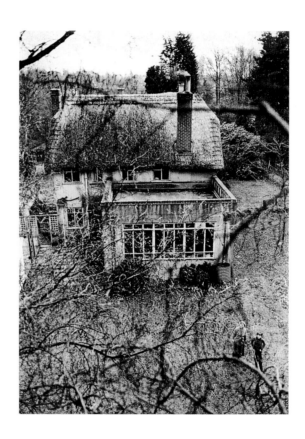

Fig. 36 Appletreewick, 1958, showing Eurich's studio
Photograph by Crispin Eurich

My parents, Richard and Mavis, a handsome young couple, came to 'Appletreewick' in the village of Dibden Purlieu on the edge of the New Forest in 1934. They had been given the land as a wedding present by Mavis's parents. When a child, she used to holiday there, staying in a hut with the family, on this rough piece of heathland adjoining her Aunt Ada's house. She remembered the train journey from London, with their hens. Richard's parents gave them the money to build a house, which was designed by Mavis's architect brother David. So the place was imbued

with a sense of tradition and family, which appealed to them both. 'Appletreewick', named after the village in the West Riding of Yorkshire, was built to last, to be a solid grounding for their marriage and their life's vision.

As the house went up, it was obvious there would be a lot of work to be done in the garden-to-be. There were gorse and heather, and underground springs, to cope with. In his diaries, Richard speaks of his routine of painting followed by work outside, laying land-drains and grubbing out gorse. The house was thatched, with Columbian pine doors and frames, quarry-tiled floors and a heavy oak front door. At the back there was a 'schoolroom' for Mavis and her friend Marion Stewart to run a small nursery school, while Richard painted in the 'white hut', further down the garden. Here he created some of his major works, including all the war paintings, some of them quite large. The studio was primitive, with no electricity, heated only by a paraffin stove in the winter. He worked there till the early 1950s, when a legacy enabled the couple to extend the house, turning the old schoolroom into the studio that was to be his workplace for the rest of his life.

The garden was as important as the house. The routine of painting followed by gardening continued. Richard planted apple-trees in the front, made flower-borders filled with large annuals and dahlias, and had a flourishing vegetable patch. There was almost an acre to manage, and at the bottom there were silver birches and a 'temple' made from wooden columns, with a felted roof. He carved in wood the figure of a woman to adorn the apex of the garage roof, her outstretched arms linked by a string of wooden beads. The trellis that linked the garage with the house was festooned with an Albertine rose. Outside the backdoor was a crazy-paving yard which he later transformed with decorative cobbling. Every time he sold a picture, in the early days, he and Mavis would celebrate by planting a rhododendron. As the years went by, some of these became massive, providing a 'play den' for their children. Also, the trees they had planted grew and grew. Richard and Mavis had the idea of marking our births with trees – Crispin and Philippa with oaks, myself, Caroline, with a horse chestnut. These trees, along with the others, came to haunt Richard, as they affected the light in the studio, creating a green shade in the summer as the light penetrated the leaves. This was a problem. Some trees were taken down or cut back, but the bare openness of the original plot could never be re-captured.

Mavis and Richard had previously been living in London. Their new home at that time offered little in cultural activities, but gradually they settled into country life, their home becoming their world. Richard played cricket in the village team. Mavis joined the Women's Institute and, later, left-wing pacifist groups.

The peace and quiet, the closeness to nature, the proximity of the sea and shipping all contributed to this inner world that the two of them fostered. For Richard it was an absolute necessity, and Mavis acquiesced.

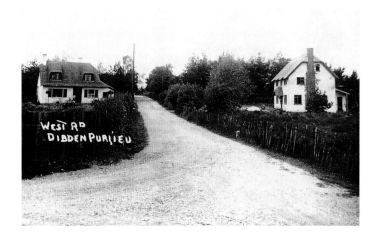

Fig. 37 Appletreewick, *ca.* 1936–37
Photograph

People would come to visit, to soak up the atmosphere, to share in the creativity on every level. But it was always a world of dreams, a sort of fortress against the material world, a 'castle' of beauty, gentleness, music and painting.

There were no paintings of Appletreewick, and only a few of the garden, even though both were so important to Richard. At the beginning he was working largely from drawings of the Dorset coast, from memories of holidays with cousins in Weymouth and his stay at Lyme Regis in the early 1930s. Then came the war years, and his work for the Admiralty. Later there would emerge the paintings for children, speaking from his imagination and his own childhood. Gradually this quality would creep into more of his work. He had been inspired by Christopher Wood, "a young man painting the things he loved". "Paint what you love, and damn all the fashions which come and go." Mavis, Appletreewick, the garden, and later his children all gave him security and provided the springboard for him to follow his dream.

Catalogue

1 Keighley Gate

Signed and dated 1922
Oil on board, 24.8 x 33 cm
Artist's estate

This is one of the first paintings Eurich made after his family moved, for the sake of his mother's health, from Bradford to Keighley. Until that time he had chiefly been fascinated by the steep streets teeming with life in the busy industrial city. By 1922 he had already discovered the allure of the sea, which he later described as representing "a symbol of a certain loneliness", and he clearly identified with the wide-open spaces of Ilkley Moor in much the same way. PS

**2 Romantic Scene,
Ilkley Quarry**

Signed and dated 1924
Oil on board, 25.4 x 33 cm
Artist's estate

Eurich described his childhood memories of
Bradford as a city with steep inclines of
granite setts and houses perched on rocks. In
this imaginary scene of Ilkley Quarry the
twenty-two-year-old artist exploits the
architectural possibilities of the rock
structures, as well as invoking the darker
aspects of Bronte-esque legend and
literature, to create an untypically romantic
scene. PS

3 Three Harlequins

Signed and dated 1926
Exhibited at the Royal Academy, 1993
Oil on board, 68.6 × 53.3 cm
Private collection

Three Harlequins is one of Eurich's most
sophisticated early paintings. At the time he
painted this work he had already been at the
Slade School for two years. Despite Professor
Tonks's disdain for modern French painting,
Eurich, along with his fellow students, had
become increasingly aware of contemporary
trends, which had been promoted by Roger
Fry and the Post-Impressionists. One of the
reports on his work at the Slade noted: "This
student is being influenced by painters who
have not been dead long enough to be
respectable". Cézanne, Picasso, Braque and
Matisse, as well as Severini, were no doubt
meant. PS

4 Mother and Child

Signed and dated 1928
Pencil and watercolour, 36.2 × 25.4 cm
Artist's estate

Although Eurich created many drawings in
the late 1920s, it was relatively uncommon
for him to colour them. The present study
combines the qualities of a primitive, but also
somewhat neo-classical, Madonna, reminiscent
of an early Miró, with the resigned pathos of
an itinerant fortune-teller seated with her
baby in front of a draped booth. The
jauntiness of the colouring, and sophisticated
innocence of the whole composition, may
derive in part from the work of Eric Gill,
whom he had met through Edward Marsh,
one of the most influential collectors of his
generation and an early patron of Eurich's. PS

5 Girl on a Terrace

Signed and dated 1928
Pencil on paper, 27.9 x 27.9 cm
Artist's estate

This and the following examples are typical of the clean, incisive, 'gothic' drawings which preoccupied Eurich in the months before his first exhibition at the Goupil Gallery in 1929. His line was more akin to that of an engraver than a natural draughtsman, and allies his work of this period to that of Robert Austin. However, already clearly defined is Eurich's sharp eye for the quirks and oddities of both man and his surroundings. Eurich later noted that over the 1928 Christmas vacation he completed a group of drawings "designed to fill the whole surface of the paper with no empty spaces left which might or might not be satisfactory when framed …" (quoted by Caroline Krzesinska, *Richard Eurich, RA, A Retrospective Exhibition* (Bradford 1980), p. 9). PS

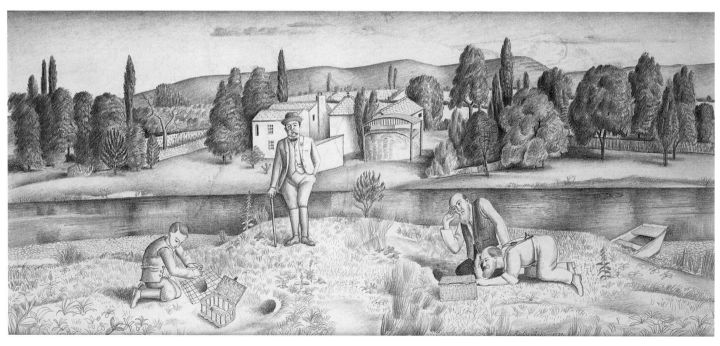

7 The Cat and Mouse

Entitled, signed and dated 1929
Pencil on paper, 38.1 x 27.9 cm
Courtesy of James Holland-Hibbert Ltd

The high viewpoint already adopted in *Girl on Terrace* (1928; cat. 5) is further accentuated in this drawing, which in turn anticipates *The Club Room* (1931; cat. 16) and its intimacy of boat-bearing water and sharply depicted buildings and streets featuring a similarly retreating figure. Something of the Italian Metaphysical painters, De Chirico and Carra, rather than direct Surrealist influence, prevails, investing the invented scene with an anticipatory atmosphere. Eurich's slightly older contemporary, James Fitton, was painting more Cézannesque cityscapes from similarly raised perspectives in this period (see fig. 31, p. 36). EC

6 Rabbiting by the River

Signed and dated 1929
Pencil on paper, 17.5 x 38.5 cm
Courtesy of James Hyman Fine Art, London

This important work typifies the attention to detail and tactile value in Eurich's early pencil drawings. Indeed at this time Eurich worked in this medium almost exclusively, and his first exhibition, in 1929, consisted entirely of drawings.

The exquisite draftsmanship and immense charm of *Rabbit by the River* bears out Nicholas Usherwood's assertion (in *The Edge of All the Land. Richard Eurich 1903–1992*, Southampton City Art Gallery, 1994) that Richard Eurich was "one of the most consistently original and artistically inventive figurative painters working in Britain over the last fifty years". EC

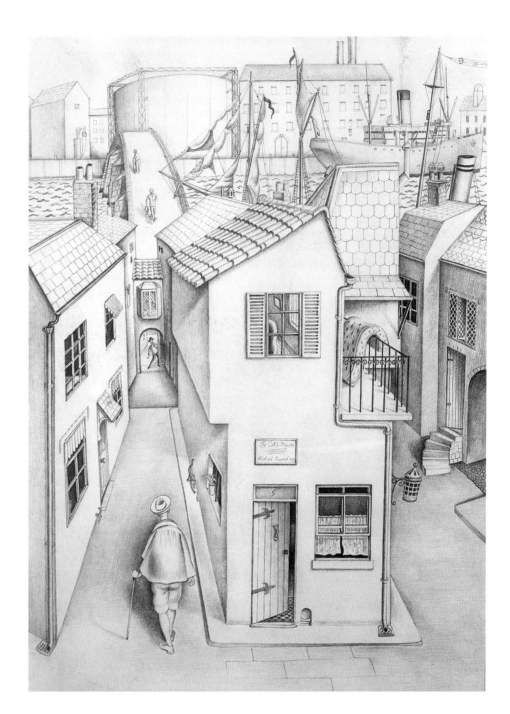

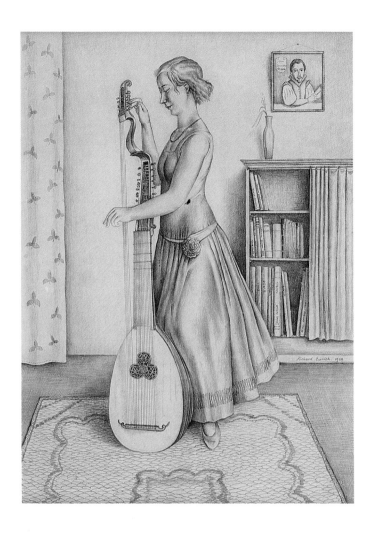

Welkes, Purcell (King Arthur), Wilbye, Parthenia, Blow, Greene Croft. The portrait on the wall is of the great composer and lutenist John Dowland (1563–1626). JH

9 The Grandfather

Signed and dated 1927 and again 1929
Pencil on paper, 37 x 27 cm
Peyton Skipwith

In this remarkable drawing, begun in 1927 and reworked two years later, Eurich prefigures the vision of the great American Regionalist painter Grant Wood (whose iconic vision of the Puritan heart of New England, *American Gothic*, was not painted until 1930). The intense scrutiny and deliberately awkward pose link the drawing with his 1929 painting *Portrait of a Gentleman* (cat. 10). PS

8 Lady with a Lute

Signed and dated 1929
Exhibited at the Goupil Gallery, 1929
Pencil on paper, 37 x 27 cm
Courtesy of James Hyman Fine Art, London

On the reverse of the original frame for this major drawing is a label, apparently in the artist's own handwriting: *18. Lady with a Lute Richard Eurich 19 Coleherne Road SW10*. Below this there is a typed label for the Goupil Gallery, so presumably the work was shown in Eurich's first exhibition.

 This drawing is exceptional large and detailed. It shows a woman standing holding a musical instrument in the lute family, which has been identified as a theorbo. The music on the bookshelves has readable text on the spines and includes: (*top shelf*) Thomas Mace, Christopher Simson; (*middle shelf*) Dowland, Robert Jones, John Daniel, Ford, Corkine, Pilkington, Grove; (*bottom shelf*) Lassus, Bull, Byrde, Gibbons,

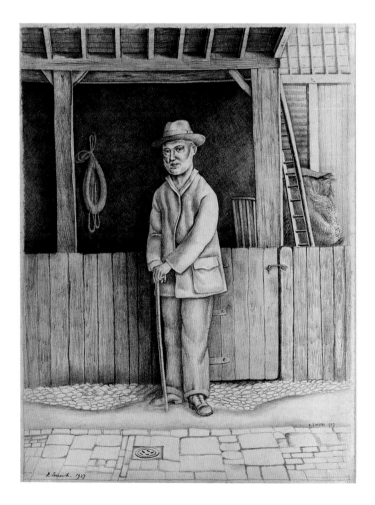

10 Portrait of a Gentleman

Signed and dated 1929
Oil on canvas, 25.4 × 17.8 cm
Courtesy of James Hyman Fine Art, London

In 1929, when Richard Eurich painted *Portrait of a Gentleman,* he also held his first exhibition at the Goupil Gallery in London, but exhibited only drawings. Subsequently, however, Eurich would turn to painting and under the influence notably of Christopher Wood would make the sea and coast his principal subject.

Portrait of a Gentleman is striking not only as one of Eurich's very first paintings but also for its combination of charm and mystery. The rosy cheeks and jaunty appearance are those of a debonair young man, whilst the grey hair that sprouts beneath his hat suggests an altogether older person. At a crucial moment for Surrealism in France, Richard Eurich, painting in England, creates an image of gentle disturbance, in which heightened detail contributes to the mystery of a work that is a good deal more startling than at first it might seem. The small dimensions belie this painting's ambition. JH

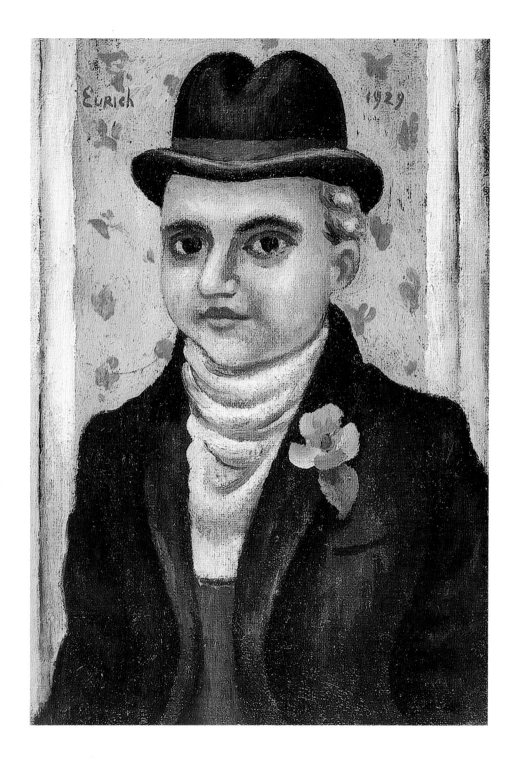

11 Portrait of a Lady

Signed and dated 1930
Oil on canvas, 66 x 49.5 cm
Artist's estate

By the end of the 1920s, despite earlier
experiments with modish styles favoured by
Mark Gertler and other slightly older
contemporaries – evident in such paintings as
Three Harlequins (cat. 3) – and following the
success of his exhibition of drawings, it was
natural for Eurich to look to earlier centuries
for inspiration. *Portrait of a Lady*, with its stiff
and self-conscious pose, contains echoes of
eighteenth-century France as well as of the
journeyman painters of England. PS

12 Sailing Ship

Signed and dated 1931
Oil on board, 31 x 46 cm
Private collection

In this painting Eurich has experimented with
trompe l'œil, a technique recently revived by
Surrealists such as Dalí, and famously
practised by Eurich's contemporary at the
Slade, Rex Whistler. A similar object features
on the wall in *The Club Room* (cat. 16). CC

13 The Drainer

Signed and dated 1930
Tempera on board, 36.8 x 46.4 cm
Artist's estate

Still life was to form an occasional but
continuing motif throughout Eurich's work; he
eschewed elaborate set-pieces in favour of
directness and simplicity, allowing any
elaboration of decoration to flow directly
from the subject – exemplified here by the
exuberant Chinese-inspired decoration of the
drainer, an otherwise functional piece of
domestic tableware. PS

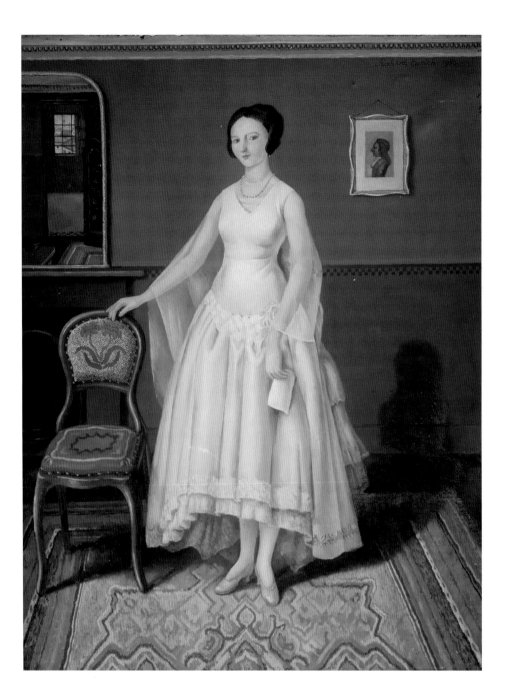

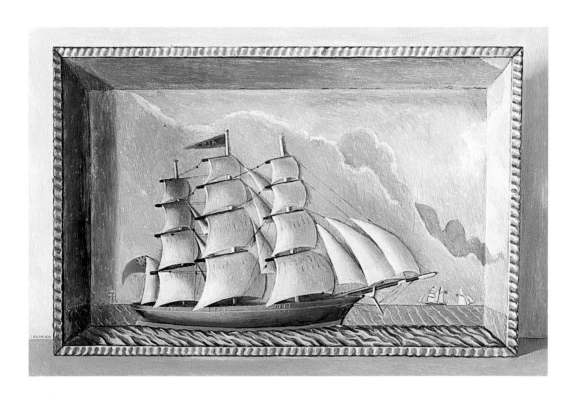

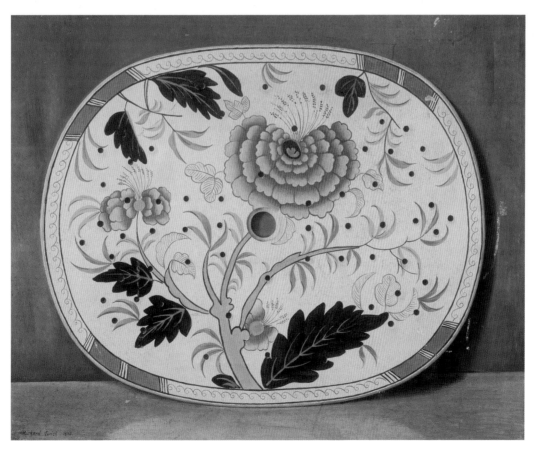

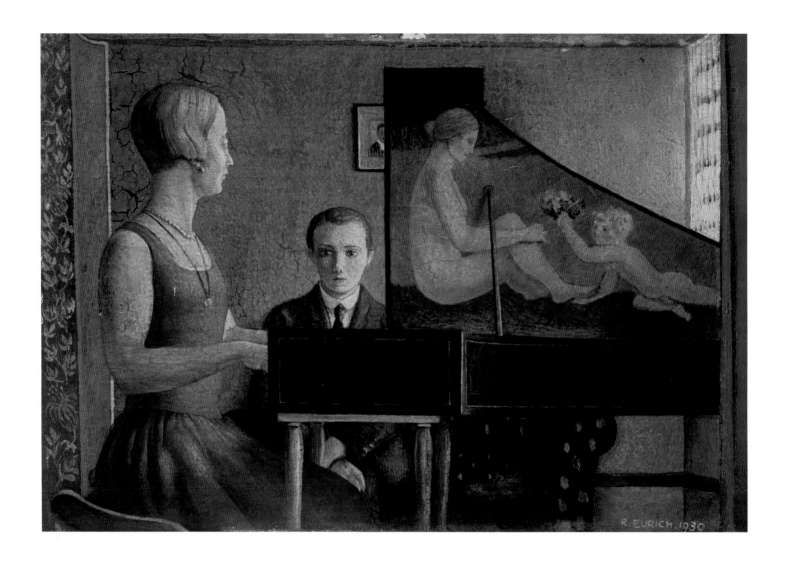

14 The Unwilling Listener

Signed and dated 1930
Oil on board, 19.7 x 27.9 cm
Private collection

In *The Unwilling Listener*, as in *Portrait of a Lady* (cat. 11), Eurich looks to earlier generations for inspiration – in this case Vermeer. But, whilst *Portrait of a Lady* is a costume piece, before *The Unwilling Listener* the viewer is left in no doubt that he is looking at an uncompromisingly contemporary work. *The Unwilling Listener* bears direct comparison with works by such widely differing artists of the period as Meredith Frampton and Otto Dix. PS

15 Boy in a Red Cap

Signed and dated 1930
Oil on board, 29.8 × 20.3 cm
Private collection

This belongs, along with *Portrait of a Lady* and
The Unwilling Listener (cat. 11 and 14), to the
group of figure paintings from the early 1930s
inspired by the Old Masters and the Antique.
In this case the inspiration seems to be a
fusion resulting from the study of Roman and
early Italian frescos. Giotto and Uccello were
two artists whose work Eurich particularly
admired at this time. PS

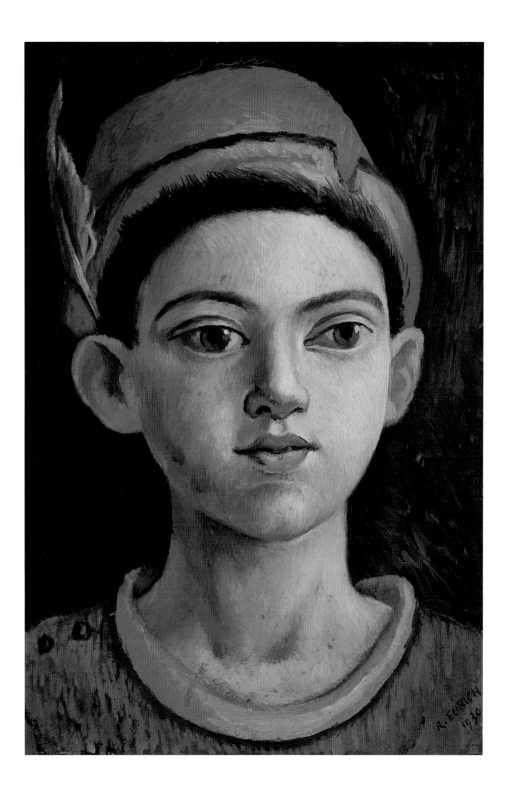

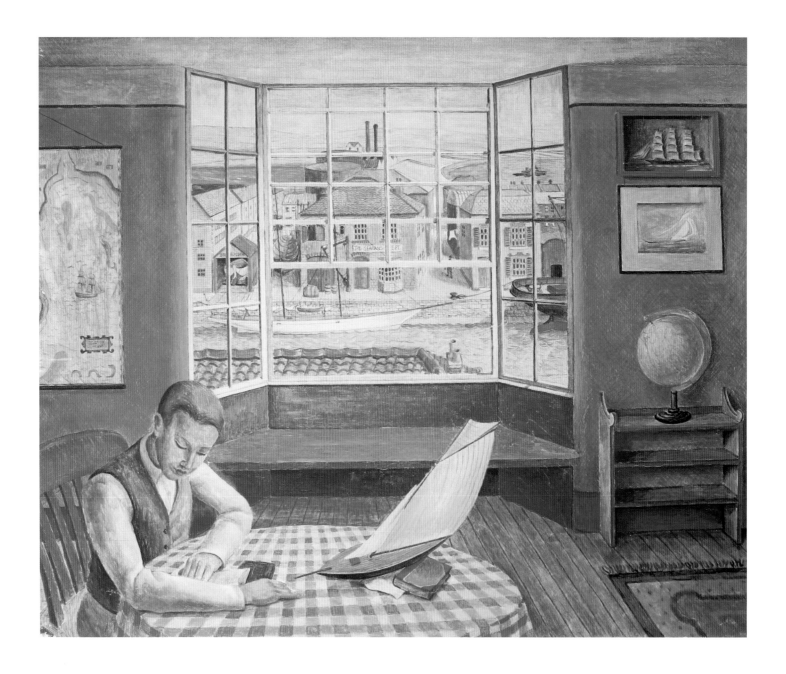

16 The Club Room

Signed and dated 1931
Exhibited at the Redfern Gallery, 1933
Tempera on board, 49.5 x 58.4 cm
The Prime Minister and Mrs Blair

A major Eurich, this picture presents the viewer with an apparently realistic scene – but one with an unnaturally high viewpoint, redolent with ambiguities. Similarly exaggerated perspective, featuring buildings, water and a figure in a sharply receding street, occurs in Eurich's 1929 drawing *Cat and Mouse* (cat. 7). Distinctive windows were also to recur in Eurich's work. In this case one looks past the reading boy and a toy boat (painted propped up as if in full sail) to two painted depictions of boats, one a *trompe-l'œil* full rigger (see cat. 12) and below a yacht more closely resembling the toy, both behind glass. Then, mainly unglazed through a raised sash window, a real yacht is seen at its mooring alongside the quay. Beyond the boathouses, hostelry and warehouses are gasometers and

then more water, either side of a Portland-like causeway connecting the foreground to a distant landscape. Yet another type of boat, probably a battleship, lies at anchor in the right-hand stretch of water. Back in the room, the way in which the boy is painted and the deliberately distorted differences between the treatment of perspective in the Bonnard-like tablecloth and floorboards reveal both Fauve and Cubist influences. Nearer to home, Henry Lamb had painted his far larger *Tea Party* in 1926 (collection of Lord Moyne): this features a group, including Stanley Spencer, seated at a round table draped with a similar chequered tablecloth, seen from above, with an almost identical bay window behind. But in Eurich's more *intimiste* creation we encounter an undertone, absent in Lamb's pictures, of Surrealist (or at least Metaphysical) atmosphere, which becomes more explicit in the 1930s. The quasi-bird's eye view of the scene outside (and to some extent inside) is echoed conceptually in the old sea chart and in the globe, which rests on a bookcase devoid of books. All in all, Eurich fills his fictional space with the richest range of reference, yet controls the whole with a mastery extraordinary for a twenty-eight-year-old. A decade later Eurich wrote to Sydney Schiff, his friend and patron, "I wish to see every painting as a world of its own". EC

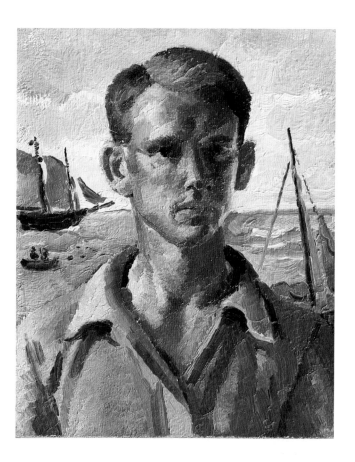

17 The Green Shirt

Signed and dated 1932
Exhibited at the Imperial War Museum, 1991; Southampton City Art Gallery, Manchester City Art Gallery, Cartwright Hall, Bradford, and Christchurch Mansion, Ipswich, 1994
Oil on board, 25.4 x 20.3 cm
Peyton Skipwith

In this small but commanding self-portrait of 1932 Eurich achieves a new freedom. Having absorbed what he needed from the Old Masters, he has confidently developed a style identifiably his own. If there is any single outside influence it is that of the lately deceased Christopher Wood, whom he had met at the Goupil Gallery in 1929. PS

18 Mavis Pope

Signed and dated 1932
Oil on canvas and board
28.6 x 25.4 cm
Artist's estate

Despite its intensity, the first portrait of Mavis Pope, painted in 1932, the same year as *The Green Shirt* (cat. 17) – two years before she was to become Eurich's wife – is a more straightforwardly direct portrait in the Italianate tradition as filtered through the eyes of Mark Gertler, John Currie, Adrian Allinson, Stanley Spencer and other artists of the immediate pre-war Slade generation, to whose work Eurich would have been introduced by Edward Marsh. PS

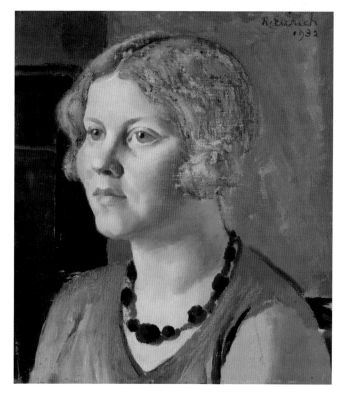

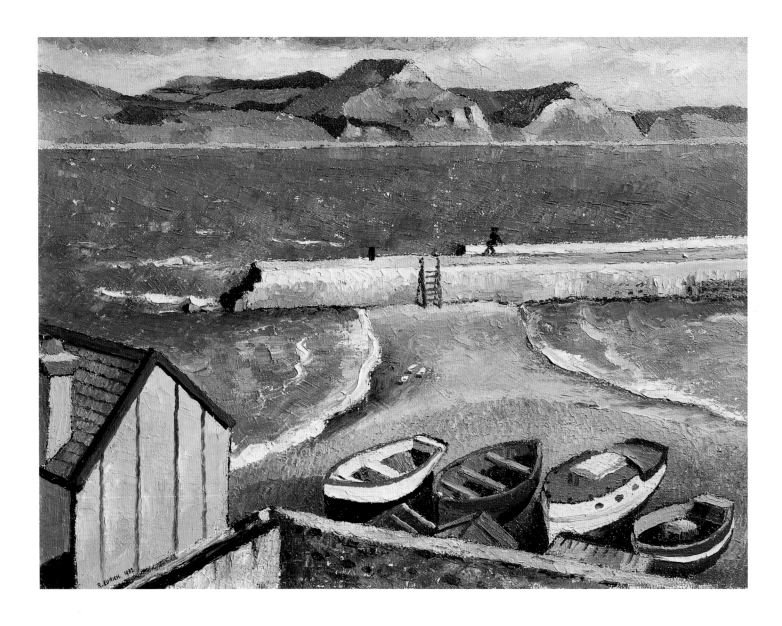

19 Golden Cap

Signed and dated 1932
Exhibited at the Redfern Gallery, 1933
Oil on canvas, 35.5 x 50.8 cm
Private collection

Golden Cap is an outstanding example of Eurich's Dorset coastal landscapes. He had been familiar with the area around Weymouth from childhood visits to his cousins, but it was as a result of a conversation with Rex Nan Kivell of the Redfern Gallery in 1932 that he decided to base himself in Lyme Regis for a time and make an intensive study of the sea and coastline. In a number of these paintings he chose to work with a palette knife rather than a brush, as though sculpting the landscape out of the raw material rather than applying it to the surface of the canvas. Nan

Kivell was delighted with the results of Eurich's sojourn in Dorset and in 1933 gave him the first of what was to be a prolonged series of sixteen exhibitions at the Redfern Gallery. *Golden Cap* was purchased by Richard's father, Dr F.W. Eurich, from the 1933 exhibition.

It was during his time at Lyme Regis that Eurich analysed and developed his extraordinary ability to paint the sea, especially the English Channel, in all its moods and in all weathers. As he recalled, he immersed himself completely in "the problems" of how to paint the sea, by which

he meant "the structure of water, not just the sea as blue background with landscapes and harbours as the main feature". This mastery, achieved in the 1930s, was to stand him in good stead when he became an official War Artist for the Admiralty. With a bold confidence, at variance with his usual self-deprecating modesty, he wrote to the War Artists Advisory Committee in June 1940:

"Now the epic subject I have been waiting for has taken place. The Dunkirk episode. This surely should be painted and I am wondering whether I would be considered for the job! It seems to me that the traditional sea paintings of Van der Velde and Turner should be carried on to enrich and record our heritage." PS

20 The Wheelbarrow, Weymouth

Inscribed, signed and dated 1933
Watercolour, 26 x 19 cm
Artist's estate

As noted above, Rex Nan Kivell offered Eurich a one-man exhibition in 1933 on the subject of the Dorset coast. All his submissions to the exhibition were in oil, but clearly while in Dorset Eurich experimented in other media, too. Harold Sawkins, editor of *The Artist*, wrote of Eurich in 1936: "Water-colour has claimed but little of his attention. I, for one, could wish it claimed more, for the few works executed in this fascinating medium have been full of respect for its limitations and are brilliant both in execution and outlook" (Harold Sawkins, 'Artists of Note: Richard Eurich', *The Artist*, XI, 6 (August 1936), p. 184) There is an interesting juxtaposition in this painting between the wheelbarrow and garden in the foreground and the warship in the distance – possibly a reference to Eurich's pacifist inclinations. CC

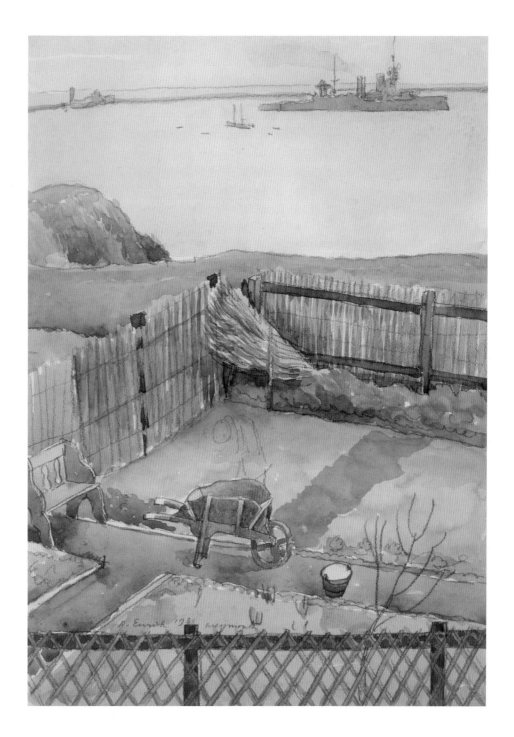

21 Still Life, Lyme Regis

Signed and dated 1933
Oil, 38.3 × 33 cm
Private collection

This meticulously detailed painting is full of
light and optimism, coincident with the
country, after four years of the Depression,
beginning its economic revival. The view
beyond the immediate still-life study is
reminiscent of Renaissance art, especially that
of the Flemish tradition. CC

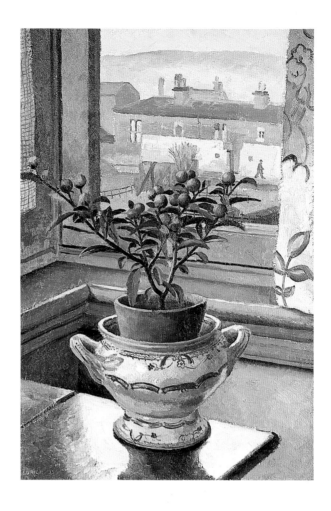

22 Portland Quarries

Signed and dated 1934
Oil on canvas, 50.8 × 76.2 cm
Artist's estate

Following his successful exhibition at the
Redfern Gallery in 1933, Eurich continued to
visit the Dorset coast. In this painting he
explores the geometrical, almost Vorticist
design of the machinery casting its shadows
against the chiselled, quasi-Cubist pattern of
the quarry face. CC

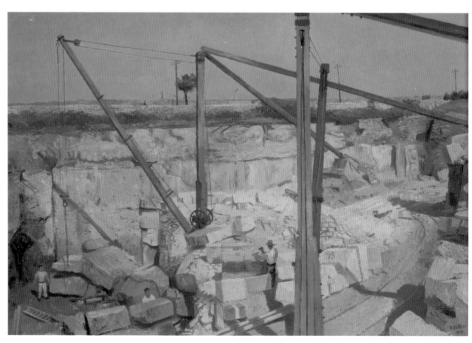

24 Mother

Signed and dated 1940
Exhibited at the Redfern Gallery, 1949
Oil on board, 45.7 × 38.1 cm
Private collection

This uncompromising portrait of the artist's Quaker mother shows a down-to-earth Yorkshire woman doggedly knitting wartime woollens. Eurich did few portraits and even fewer outside his family. In 1944 he was placed in a quandary when his friend and patron, Sydney Schiff, asked him to paint his wife, Violet. Eurich, who went through periods of doubt about his talent, replied: "I feel very honoured by your faith in my ability ... and wonder whether I could do it or not. There are great difficulties you know, and I would hate to waste the sitter's time and energy ... for a failure" (Letter from Richard Eurich to Sydney Schiff (2.4.44), Tate Gallery Archive, (8813.97)) PS/CC/EC

23 Portrait of Mavis

Signed and dated 1935
Oil on board, 32.4 × 26 cm
Artist's estate

In contrast with the 1932 portrait (cat. 18) of Mavis Pope, who was by now his wife, the artist shows a slimmer, more confident woman, depicted full face, dressed in a riding jacket with hands thrust into her coat pockets. Her slightly averted gaze gives the portrait a relaxed rather than a confrontational air. PS

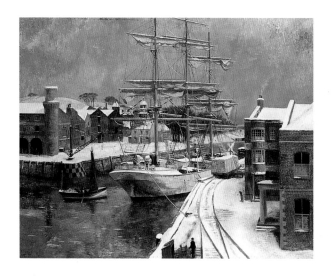

BRITAIN AT WAR

EDITED BY MONROE WHEELER. TEXT BY T. S. ELIOT, HERBERT READ, E. J. CARTER AND CARLOS DYER

THE MUSEUM OF MODERN ART, NEW YORK

25 December, Work Suspended

Signed and dated 1940
Exhibited at the Royal Academy, 1940;
Cartwright Hall, Bradford, 1951, 1980 and
1984; Southampton City Art Gallery,
Manchester City Art Gallery and
Christchurch Mansion, Ipswich, 1994
Oil on canvas, 101.6 x 127 cm
Ferens Art Gallery, Hull City Museums & Art
Galleries

The normality of this quiet scene of an
imaginary harbour belies the outbreak of the
Second World War. In a matter of months
Paris would fall to the German armed forces
and the British Expeditionary Force would be
trapped at Dunkirk. Eurich, who initially
thought he would be unable to paint for the
duration of the War, found fresh inspiration
and applied to become an official War Artist.
CC

26 Britain at War, illustrating The Withdrawal from Dunkerque (1940)

Edited by Monroe Wheeler, exhibition
catalogue, The Museum of Modern Art,
New York, 1941
Edward Chaney

Eurich's Withdrawal from Dunkerque was
illustrated both on the dustjacket and as the
frontispiece of Britain at War, the catalogue of
a major exhibition designed to illustrate both
Britain's war effort and contemporary visual
culture. It was published in an edition of
10,000 copies. Eurich's picture, now in the
National Maritime Museum, was shipped to
America for the exhibition, having first been
shown to great acclaim at the National
Gallery in London. Another Eurich, Dunkerque
Beach of May 1940, was shown at the Royal
Academy in 1941 and acquired by Vincent
Massey for the Canadian War Museum. EC

27 A Destroyer Escort in Attack

Signed and dated 1941
Exhibited at the Cartwright Hall, Bradford,
1951; Imperial War Museum, 1991
Oil on canvas, 50.8 x 101.6 cm
Birmingham City Museums and Art Gallery

In contrast to the stillness of December, Work
Suspended (cat. 25), this action painting shows
the destroyer escort to a merchant convoy
sweeping across the horizontal plane of the
picture in pursuit of U-boats. Eurich has used
a cinematic-style action shot to capture the
speed and urgency of the destroyers, with
the foreground vessel moving out of frame to
the right and another entering from the left.
As always, his rendition of water is masterly.
CC

28 Bombardment of the Coast near Trapani, Sicily, by HMS Howe and King George V, 12 July 1943

Signed and dated 1943
Exhibited at Cartwright Hall, Bradford, 1980;
Imperial War Museum, 1991
Oil on canvas, 76 x 127 cm
National Maritime Museum, London

Eurich's love of Turner had been honed early
in life, when he was given access to the
extraordinary collection formed by Turner's
patron Walter Fawkes at Farnley Hall, near
Ilkley. Three in particular of his great war-time
paintings bear witness to his admiration and
understanding of Turner's mastery of the sea:
Bombardment of the Coast near Trapani; The
Raid on Vaagso, Norway and The Landing at
Dieppe. The first of these epic paintings, The
Withdrawal from Dunkerque (see cat. 26), had
already revealed Eurich's ability to absorb and
unify his own experience with diverse
secondary sources of information. He did not
witness in person the great events which he
recorded so passionately and dramatically, but
with his knowledge of the "structure" of the
sea, combined with sketches made whilst
travelling along the Franco-Belgian coast, eye-
witness accounts and photographs, he was
able, quickly and masterfully, to interpret
these scenes not only as great art, but in a
manner that convinced those who had
participated of their absolute veracity. PS

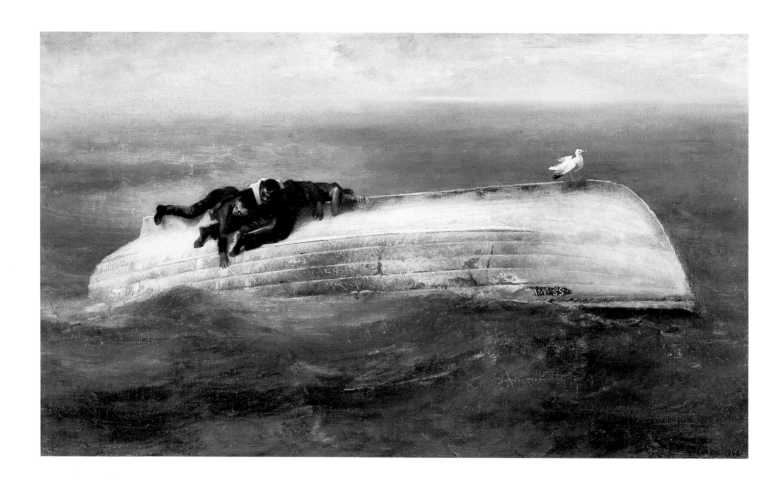

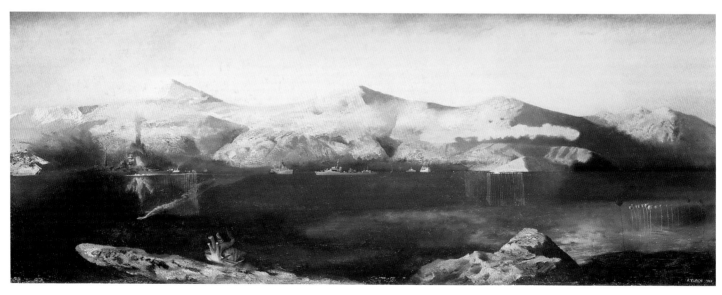

29 Survivors from a Torpedoed Ship

Signed and dated 1943
Exhibited at the National Gallery, 1943;
Cartwright Hall, Bradford, 1980; Imperial War
Museum, 1991
Oil on canvas, 35.6 × 61 cm
Tate, London

Recording the great dramas of war at sea did
not deflect Eurich from depicting those lesser
and often quirky incidents which throughout
his life were to capture his imagination:
Survivors from a Torpedoed Ship is one such, in
which the wet and bedraggled castaways (not
all of whom did survive) cling for dear life to
the stern of an upturned lifeboat, whilst a
seagull proudly stands look-out at the prow.
PS

30 The Midget Submarine Attack on the Tirpitz, 22 September 1943

Signed and dated 1944
Exhibited at the Royal Academy, 1945;
Imperial War Museum, 1991
Oil on canvas, 40.5 × 106.5 cm
National Maritime Museum, London

Consistently original in his approach, Eurich
has used a panoramic view of Alten Fjord in
order to show the Royal Naval midget
submarines attempt their escape while their
mines explode on target. Although the *Tirpitz*
was not sunk following this action, it was out
of commission for many months, enabling the
North Atlantic convoys to proceed with a
slightly greater degree of safety. Eurich has
included a sea monster on the floor of the
fjord, possibly in homage to Turner, whose
Sunrise with Sea Monster (*ca*. 1845) is in the
Tate's collection, or perhaps as a metaphor
for nature caught up in human conflict. CC

31 House by the Beach

Signed, 1945
Exhibited at the Redfern Gallery, 1945
Oil on board, 22.9 × 30.5 cm
Courtesy of James Hyman Fine Art, London

In October 1943 Eurich wrote to his friend
and patron, Sydney Schiff: "I am just starting
to paint at odd moments a set of little
pictures as Christmas presents for some of
my nephews and nieces, and it has put into
my mind a scheme which might interest Nan
Kivell I have always wanted to indulge in
free fancy and humour occasionally and this
seems to be a good way of liberating it,
besides giving a freedom and opening up
ideas in more serious work" (Richard Eurich
to Sydney Schiff (27.10.43), Tate Gallery
Archive (8813.85)). The project reached
fruition in the exhibition entitled 'Paintings for
Children' at the Redfern Gallery in 1945.

This beautiful small painting is charming, yet
has a sense of expectation and even menace.
It recalls not only the whimsy of Eurich's
paintings of the late 1920s and 1930s but
also the dark, dramatic skies of his celebrated
wartime paintings of the 1940s. Painted at
the war's end, *The House on the Beach* is a
summation of many of Eurich's key themes:
we are shown a beach on which boats lie
awaiting high tide. People look out
expectantly, a fishing boat is tossed by the
turbulent sea, and dominating the scene is the
glowing presence of an imposing, yet
welcoming house. JH

32 Mother and Baby

Signed and dated 1946
Exhibited at the Redfern Gallery, 1949
Oil on board, 20.3 x 15.9 cm
Artist's estate

This tender image was painted in the year following the conclusion of the Second World War and perhaps intentionally has resonances of the women and children who suffered in the death camps; Eurich, having heard news of Dachau in 1942, had already painted work in response to the horror. But the picture also recalls the recent work of Henry Moore, whose sketches of figures sheltering in the Underground during the London Blitz were so haunting. It is clearly also a modern reworking tapping into the compassion of Madonna and Child paintings from the Italian Renaissance. CC

33 The Mummers

Signed and dated 1952
Exhibited at the Royal Academy, 1952; The Fine Art Society, 1977; Cartwright Hall, Bradford, 1980
Oil on board, 88.9 x 88.9 cm
Brighton Museum and Art Gallery

After the War Eurich never again attempted anything as ambitious and challenging as *Bombardment of the Coast near Trapani* (cat. 28) and his other great scenes of naval conflict, forgoing the drama of world events for the mundane and unremarkable events of everyday life. Three main strands were to recur in Eurich's work during the last four-and-a-half decades of his life: the Solent as viewed from Lepe beach, near Dibden Purlieu, where he and Mavis had settled in 1934; scenes such as *The Mummers*, inspired by childhood memories of Bradford; and small, quirky paintings triggered by oddities seen from the corner of the eye. PS

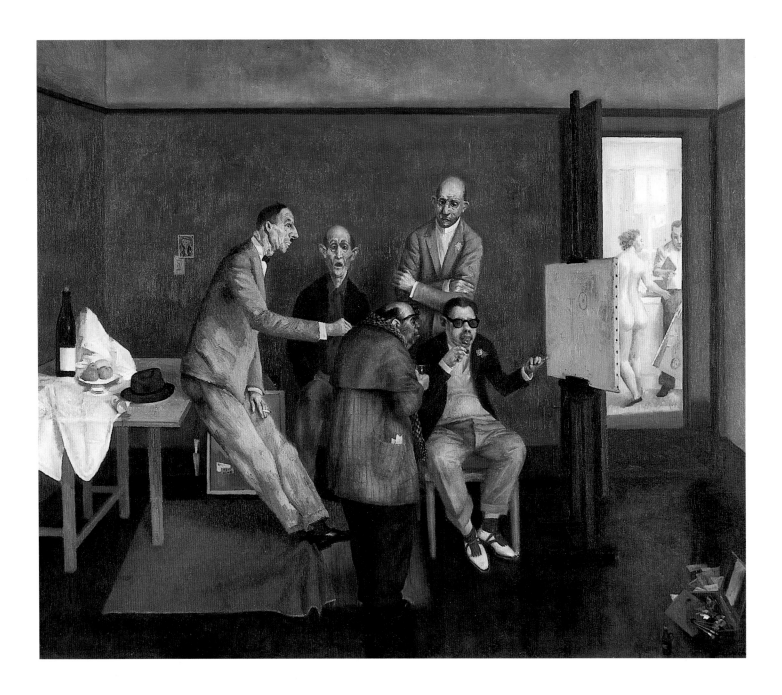

34 The Critics

Signed, 1956
Exhibited at the Royal Academy, 1956;
Redfern Gallery, 1956; Southampton City Art
Gallery, Manchester City Art Gallery,
Cartwright Hall, Bradford, and Christchurch
Mansion, Ipswich, 1994
Oil on Canvas, 63.5 x 76.2 cm
Harriet Waugh

In 1956 the Tate Gallery exhibition 'Modern
Art in the United States' signalled the arrival
of the Abstract Expressionists in the London
art world, which they would subsequently
dominate. Their favourable critical reception
continued a tradition, established by
Bloomsbury, whereby indigenous talent was
disregarded and denigrated according to an
internationalist agenda institutionalized by
critics promoting their own specialized taste.

That same year, the Royal Academy's Summer
Exhibition displayed two pictures satirizing
this milieu. One was a high-spirited and good-
natured satire by Alfred Munnings, attacking
the purchasing policy of the Tate Gallery and
its then director John Rothenstein, entitled
Does the Subject Matter?. The other, Richard
Eurich's *The Critics*, was a darker and more
sinister invention. Though both received press
coverage at the time, only Munnings's *Does*

the Subject Matter? remains known today. *The Critics*, since being purchased by Evelyn Waugh, has been largely forgotten.

As a consequence of its relative invisibility, however, Eurich's picture is open to fresh interpretation. Whereas *Does The Subject Matter?* has lost much of its satiric novelty, *The Critics*, in contrast, retains its power to shock undiminished by time: its "coldly accomplished savagery" (*The Times*, 5 May 1956) is intact. Implicit in *The Critics* is an alternative commentary on the art of Eurich's time, an attack on a conspiracy of taste which outlawed what he held dear. These critics admire the abstract picture of a circle and line and in doing so turn their backs upon the Cézannesque still life on the table on the left and the figurative painter with model working in the back room.

The Critics is a disconcerting work. Eurich so cruelly depicts his subjects that one is immediately repulsed. This is exactly the response Eurich seeks to evoke. He employs caricature to portray a group of critics he feels are ludicrous and corrupt; it is the kind of caricature we find in Jonathan Swift, Hogarth, Thomas Patch, Wyndham Lewis's *Apes of God* and George Fullard's *Politicians*.

Eurich revealed in a letter to Richard Dorment in 1987 the origins of these "badly dressed representatives of the monkey house" (*Southampton Daily Echo*, 10 May 1956). The painting, he wrote, was "triggered off by the critic on the left ... he was at the press view at the Royal Academy and he told me (dandling a glass of sherry) that he had just had some fun writing an obituary notice for A.J. Munnings who at the time was P.R.A. and very much alive and kicking. I was disgusted." The implication is that the critics in the painting are based on real people (confirming the suspicions of Eurich's friend and chess opponent T.C. Stanley Little in the *Southampton Daily Echo*, 10 May 1956), although it is also less specifically an expression of the creative artist's age-old dislike for the middleman. It is not likely that such an extreme reaction on Eurich's part would have been the result solely of one critic's insensitive remarks about a fellow artist.

Perhaps it was Munnings himself, in whom Eurich may have confided, who encouraged Eurich to take the braver step and produce a public diatribe against the London art world of the time.

The painting offers up to ridicule a microcosm of fashionable London art society, with all its machinations. These are critics "ready to plug to the hilt, to trumpet, to expound, any movement in painting… which was obviously hurrying along a path as opposite as possible from what had appealed to civilised man through the ages" (Wyndham Lewis, *The Demon of Progress in the Arts* (London 1954), p. 53). Behind the savage treatment lies an honest and intensely felt despondency. In the art world Eurich knew, critical success is achieved through formal innovation at the expense of that combination of tradition and individual talent which T.S. Eliot had championed and Eurich steadfastly refused to abandon.

Although the identities of Eurich's targets must remain speculative, since he was unwilling to divulge them while he lived – thus disappointing Richard Dorment, who made the first attempt at uncovering the mystery in 1987 – suggestions can be made. The critic on the left may be Alan Clutton-Brock, who is remembered as an enormously tall man and a dandy. He wrote an introduction to French painting, published in 1932, and was the anonymous art critic for *The Times* during the 1950s – a position which would have enabled him to make the sort of comments about Munnings that so infuriated Eurich. Next to this figure, with hands thrust into his pockets, is perhaps the art critic David Sylvester. As well as being a champion of Francis Bacon and the School of London painters he also, during the 1950s, supported the abstractions of Hans Hartung, Nicolas de Stael, Alan Davie and Victor Pasmore, a list that by 1956 extended to include the Abstract Expressionists.

It is probably due to John Rothenstein's tenure as director of the Tate Gallery (1938–64) that he is so brutally, almost anti-semitically, represented here, hunched and holding a goblet. Although a director of wide-ranging taste, he came to be seen as an enemy of Royal Academicians in the wrangle over the Chantrey bequest and in his attempts to create a comprehensive collection of modern art at the Tate. It is ironic that Munnings and Eurich seemed to have shared a view of Rothenstein as an advocate of abstract art when he did so much to promote twentieth-century figurative art and British art in particular.

The figure with arms folded and large ears standing in the background is a more difficult question. One possibility is the art critic and historian J.P. Hodin. Although famous for his studies of Munch and Kokoschka, Hodin may have become a target for Eurich as a result of his association with Herbert Read's Institute of Contemporary Art, where he was director of studies from 1949 to 1954, delivering the first complete lecture course in England on the modern movement in the arts. Throughout the 1950s he was a regular contributor to art journals and a year after *The Critics* was exhibited published a book eulogizing Ben Nicholson's abstract works.

Arguably the most grotesque creation is the seated figure. This is probably Philip Laski, the brother of the novelist and critic Marghanita Laski, who during the 1950s acted as a consultant to a London Gallery located in George Street which specialised in small-scale Surrealist and abstract works. One art critic remembered him as always having greased-back black hair, always wearing a pair of dark glasses, and, when his black jacket was unbuttoned, there was visible a canary yellow sweater.

It is a sobering thought that the orthodoxy Eurich attacked – dictating set criteria and militating against figurative art – has continued unabated. Had Eurich been working today his victims would perhaps have been a group of Turner Prize judges. DM

35 Hot Day in the Village

1952
Exhibited at the Redfern Gallery, 1952
Oil on board, 20.3 × 17.8 cm
Private collection

This gently humorous painting delights as much in the
quiet ways of the countryside as in the strong colours of
high summer. In a reaction to his intense years spent as an
official War Artist to the Admiralty, Eurich turned to urban
and rural subjects and treated them as celebrations of
human life. CC

36 Elephant Boy

Signed and dated 1956
Oil on board, 101.6 × 76.2 cm
Private collection

It is unclear whether this elephant with its two boy
handlers (perhaps related to Kipling's *Kim*) is meant to be
in India or if it is part of a circus act. The air of mystery is
heightened by the darkness that surrounds the central
subjects, in which the bulk of another, recumbent,
elephant can just be discerned on the right. CC

37 Richmond, Yorkshire

1958
Printed poster, 50.8 × 76.2 cm
Private collection

This poster was commissioned by the General Post Office
as part of their 'correct addressing' campaign of the late
1950s. It is likely that the figure in the foreground, holding
the map of Richmond, is an imagined self-portrait as a
boy. Similar self-portraits appear in *The Mummers* (1952;
cat. 33) and *Queen of the Sea, 1911* (1954; The Royal
Academy of Arts). CC

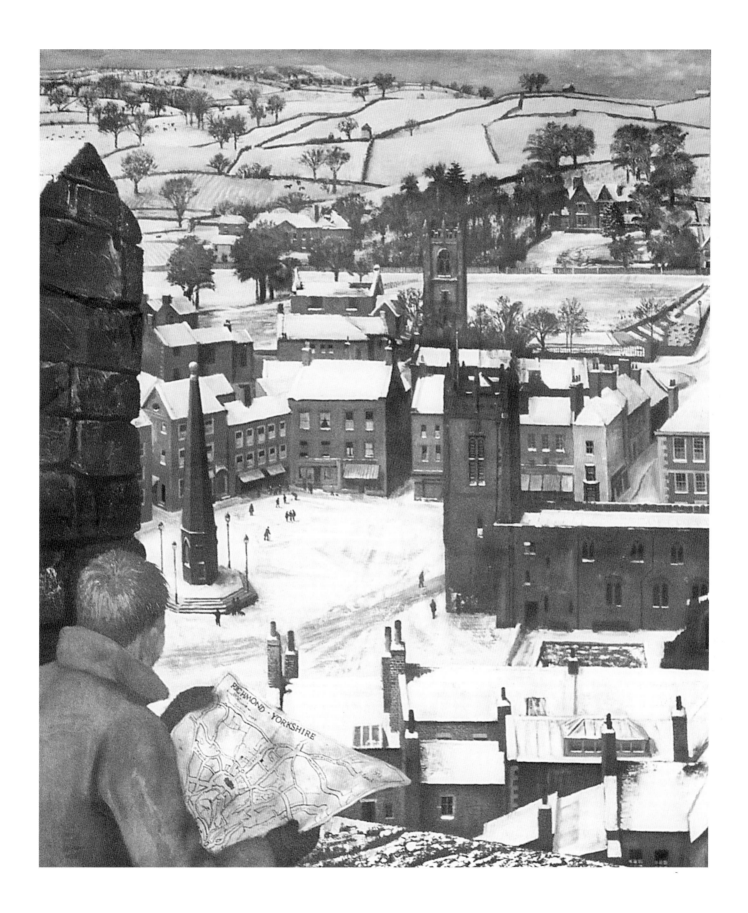

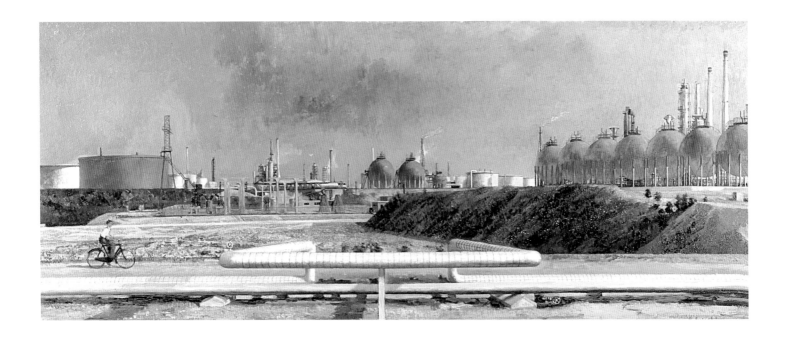

38 A Refinery Scene (The Seven Sisters)

Signed and dated 1960
Oil on board, 120 x 50 cm
Esso

The subtitle for this painting, *The Seven Sisters*, refers to the seven spherical liquid petroleum gas tanks on the right of the picture that are still very much a feature of the Esso oil refinery at Fawley on the shore of Southampton Water. Though the intention of the commission was evidently to celebrate the technological prowess of Esso's state-of-the-art plant, Eurich has created a hushed and dignified, albeit somewhat inhuman, composition animated only by the cyclist entering from the left and the wind-swept 'Fawley flames' flaring in the same left-to-right direction. The artificially symmetrical arrangement of the pipes in the foreground reminds one both of the abstract painting now dominating the period but also of the industrial landscapes of artists such as Jeffrey

Smart. Just as, when he painted *Survivors from a Torpedoed Ship* (cat. 29), he insisted on painting the situation realistically, here Eurich has done little to idealize the reality of the scene, though he has carefully organized it into a beguiling, indeed colourful composition that encourages a reflective response.

Eurich's son, Crispin, a well-known photographer, found Fawley Refinery a fascinating subject, and held a one-man exhibition of his pictures of it, sponsored by Esso, in the early 1960s. Eurich himself featured the 'Fawley flame' again in the night sky of *Sir Francis Chichester's Return to Buckler's Hard*, painted for Lord Montagu in 1967. EC

39 Still Life

Signed and dated 1959
Oil on board, 27.9 × 31.8 cm
Private collection

Eurich demonstrates in this, as in *Still Life, Lyme Regis* (1933;
cat. 21), both his ability to paint glazed and translucent surfaces
convincingly and his subtle handling of light and shadow. CC

40 Study from an Alabaster Carving

Signed, 1964
Exhibited at the Royal Academy, 1964; Ash Barn Gallery, 1984
Oil on board, 50.8 × 40.6 cm
Artist's estate

The extraordinary and moving *Study from an Alabaster Carving* is
directly inspired by a polychromed Nottingham alabaster relief
of the Deposition and is imbued with a quiet piety redolent of
pre-Reformation Christianity. PS/EC

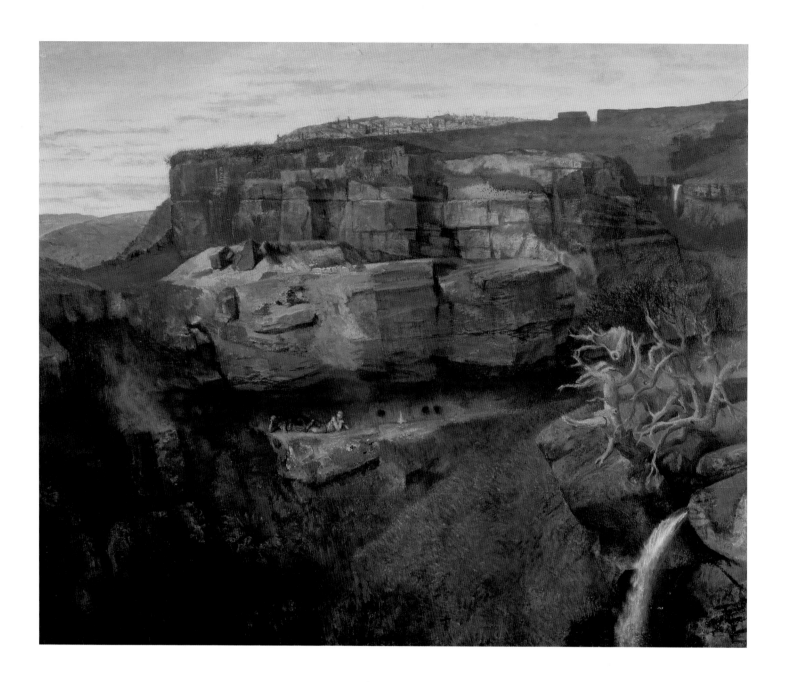

41 Hanging Stone

Signed and dated 1969
Exhibited at Arthur Tooth & Co., 1970
Oil on canvas, 64.8 × 76.2 cm
Private collection

Every summer Richard and Mavis Eurich would travel up to Yorkshire for a holiday with his sister, who continued to live in the county. There he delighted in painting remote landscapes such as *Hanging Stone*, with its evocative name and suggestion of a prehistoric presence. The artist seems to have stumbled across a neolithic settlement in the Yorkshire Dales. CC

42 Hillside in Wales

Signed and dated 1967
Exhibited at The Fine Art Society, 1991
Oil on board, 45.1 x 59.7 cm
Artist's estate

R. Eurich 2 oct. '69.

R. Eurich. '69.

43 Mirage

Signed and dated 2 October 1969
Exhibited at the Royal Academy, 1970; The
Fine Art Society, 1991
Oil on board, 10.8 x 26.7 cm
Artist's estate

This painting has a Turneresque element of
abstraction, but is unmistakeably Eurich's
response to nature. He is one of those
artists who can permanently transfigure
nature for those who allow themselves to be
seduced by his vision. One's experience of
the sea and the Solent is greatly enhanced by
study of Eurich's paintings of it. EC

44 Gathering Storm

Signed and dated 1969
Exhibited at The Fine Art Society, 1977
Oil on board, 20.3 x 30.5 cm
Edward Chaney

This is a beautifully concise evocation of the
Solent, a tanker moving inexorably towards
its destination beneath an impending evening
storm. Cloud, sea and sky are depicted in
colours manipulated so instinctively that they
become parallel realities or satisfying
alternatives to real elements. The picture's
sombre mood may reflect the artist's own
feelings, at the end of a difficult decade. EC

45 Chesil Beach from Rodwell

Signed and dated 1974
Oil on board, 40.6 x 61 cm
Artist's estate

This serene painting returns to the coast near
Portland and includes one of Eurich's
favourite motifs, the mark of mankind upon
the landscape. CC

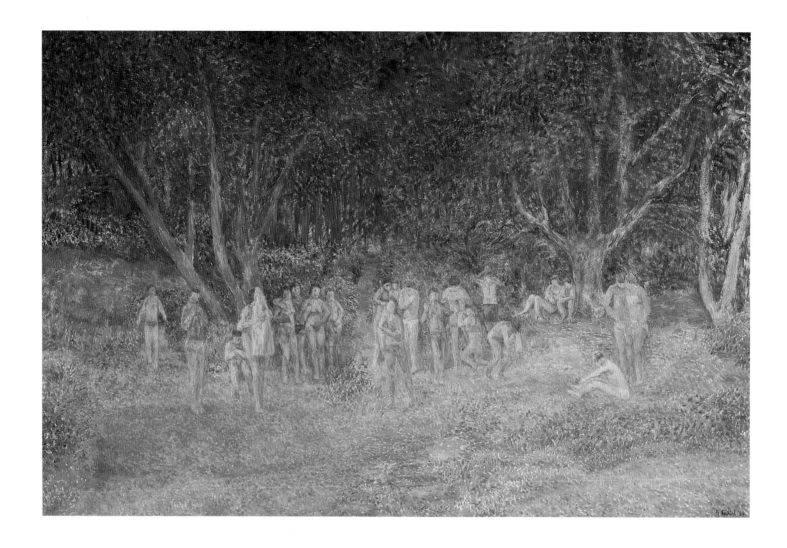

46 The Burning Bush

Signed and dated 1984
Exhibited at the Royal Academy, 1985
Oil, 30.5 × 45.7 cm
Private collection

A group of figures is gathered by a fire and close to a wood, a place of psychological transition. How the painting relates to its title is unclear, but the subject would appear to be mystical. An immediate association would be with the biblical story of Moses and the Burning Bush, but Moses was alone in the wilderness of Midian with his father-in-law's flock of sheep on Mt. Horeb at the time (Exodus 3:1), while this painting contains none of these narrative elements. More

generally, Eurich often painted fires in a landscape, as in his mysterious *Burning Tree at Studley Royal* of 1977 or *The Last of the Guy* of 1983 (cat. 56). CC

47 Dymchurch Sands

Signed and dated 1974
Oil on board, 19.7 × 34.3 cm
Private collection

48 Pebbles

Signed and dated 1978
Oil on board, 20.3 × 35.6 cm
Artist's estate

This carefully arranged still life, with direct overtones of the *objets trouvés* which were the inspiration for so many of Henry Moore's maquettes, is similar in approach to the small figure compositions Eurich painted during the last twenty years of his life. Innocent props, like isolated notes in a musical score, are just there to be observed for their intrinsic mystery. PS

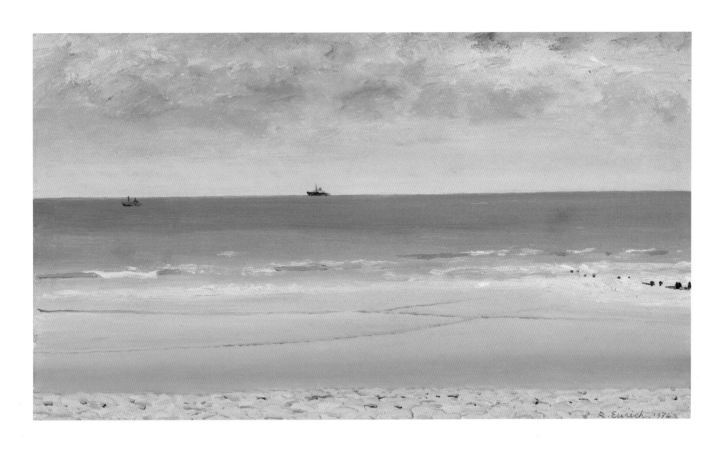

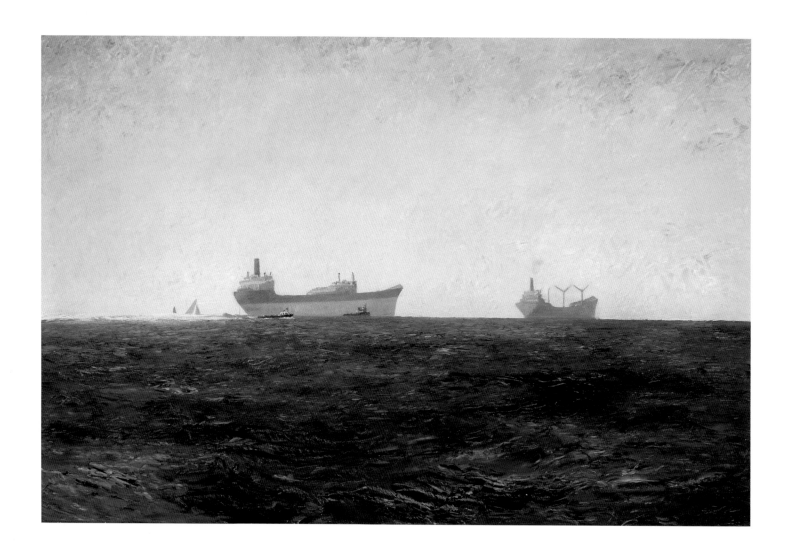

49 Dark Solent with Tankers

Signed and dated 1980
Oil on board, 50.8 x 76.2 cm
Artist's estate

Dark Solent with Tankers shows Eurich working on a more substantial scale, with dark water and massive tankers on the horizon. PS

50 Yachts in a Squall

Signed and dated 1980
Oil on board, 29.2 x 64.8 cm
Artist's estate

It was from the Solent that Eurich derived his most enduring inspiration, returning day after day, night after night, year after year, just to sit and watch, analyse and note the "structure" of the water and the weather. Rain, snow, fog or sunshine were depicted again and again in the early morning, the middle of the day, early evening or after dark – sometimes, as in *Blizzard* and *Broken Cloud*, with no narrative detail. If it were not for Eurich's deep love of nature and the elements these could almost be viewed as totally abstract compositions. Other works, such as *Yachts in a Squall*, are full of activity, the animated paint-surface emphasizing the turbulence of the scene and reminding the viewer once again of Eurich's life-long admiration for Turner. Sometimes he would depict the water with no reference to the land, at other times the beach would become an important element. PS

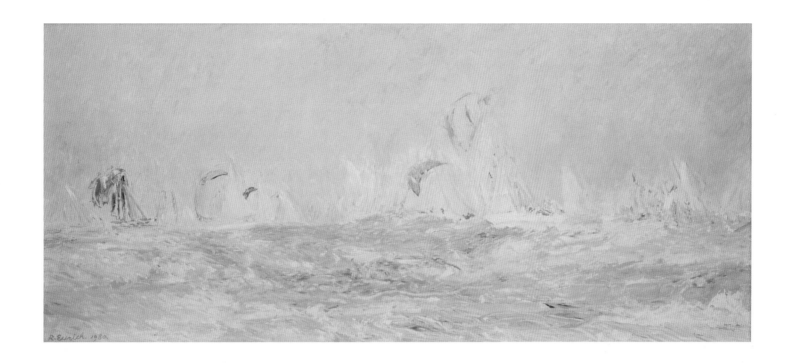

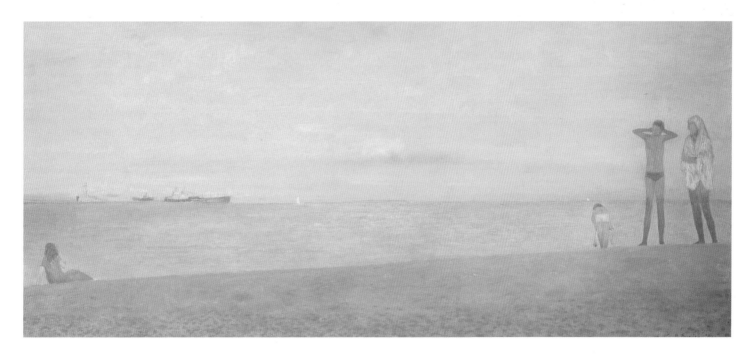

51 Evening, 1980

Signed and dated 1980
Oil on board, 40.6 x 91.4 cm
Artist's estate

Evening, 1980 is full of tension: a solitary
figure sits on the extreme left-hand side of
the composition watching a distant tanker
sailing inexorably towards the family trio
standing on the extreme right, stark against
the skyline. PS

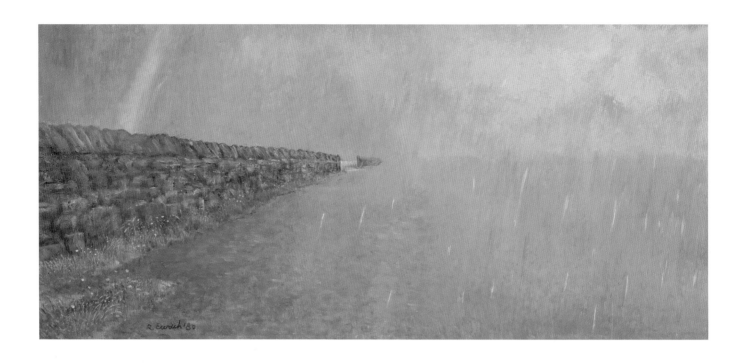

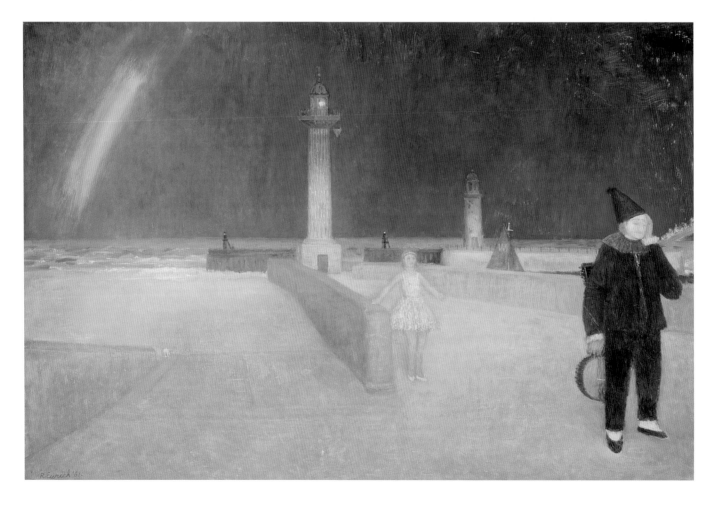

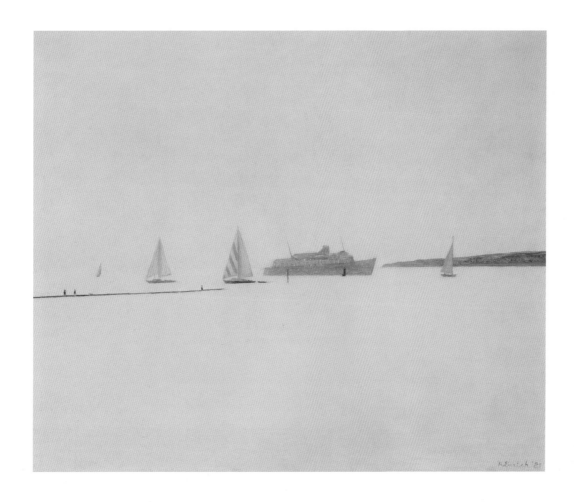

52 Rain Landscape

Signed and dated 1980
Exhibited at The Fine Art Society, 1983
Oil on board, 22.9 x 48.9 cm
Artist's estate

The familiar sight of a rain-soaked landscape and a rainbow could carry biblical connotations of the Flood and the Noahic Covenant, the reconciliation between God and mankind (Genesis 9:8-17). A rainbow is also mentioned in Revelation 4:3. CC

53 Moment of Sadness

Signed and dated 1981
Exhibited at the Royal Academy, 1981 and 1993; The Fine Art Society, 1983 and 1991; Ash Barn Gallery, 1984
Oil on board, 50.8 x 76.2 cm
Artist's estate

Moment of Sadness revisits several themes featured in Eurich's paintings, going at least as far back as *Three Harlequins* of 1926 (cat. 3). The clown, no longer performing, and separated from his fellow performer/ daughter/lover, is about to depart from the scene, which itself is an ambiguous one between land and sea, day and night, joy and sadness. The rainbow and lighthouse occur in the more realistic and noisier but no less mysterious *Coastal Scene with Rainbow* (1952;

Government Art Collection: Nicholas Usherwood, *The Edge of All the Land: Richard Eurich 1903–1992* (Southampton, 1994), no. 50), and a full rainbow hovers over *The Rescue* (1971–74; no. 70). EC

54 White Solent

Signed and dated 1981
Oil on board, 50.8 x 61 cm
Artist's estate

The ever varying effects of light upon the waters of the Solent are familiar to all who live along its shores. *Dark Solent with Tankers* (cat. 49) and *Storm Brewing* (1988) are similar examinations of meteorological effects upon the colour and activity of sea water. CC

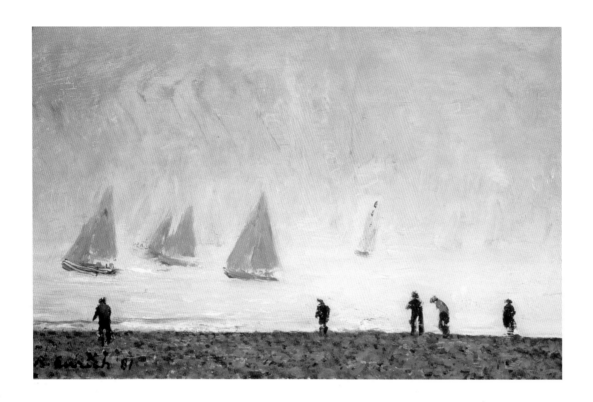

55 Rain in the Solent

Signed and dated 1981
Oil on board, 14.6 x 21.6 cm
Artist's estate

After his retirement from Camberwell School
of Art in 1968, Eurich visited Lepe beach, on
the shore of the Solent, almost every day, and
always with his sketchbook. This is one of
many delightful small paintings completed in
these years. CC

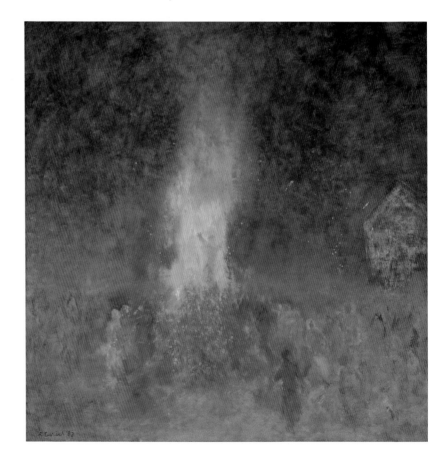

57 The Black Tent

Signed and dated 1983
Oil on board, 45.7 × 30.5 cm
Artist's estate

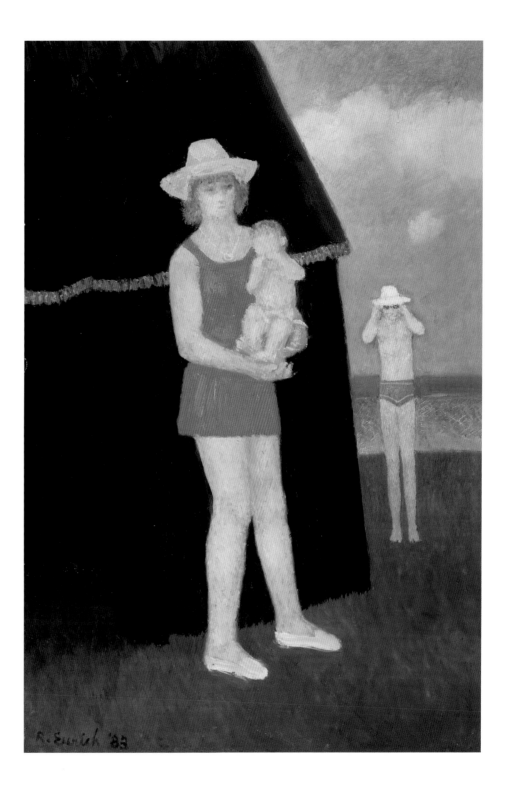

56 The Last of the Guy

Signed and dated 1983
Exhibited at the Royal Academy, 1984
Oil on board, 61 × 61 cm
Artist's estate

In none of Eurich's earlier paintings about
scarecrows, such as *Battle of the Boggarts*
(1948; private collection); *Men of Straw* (1957;
Nottingham Castle Museum and Art Gallery);
The Guy (1958; fig. 27, p. 28) are they ablaze.
This autumnal scene, in which all form
dissolves in light, is very much the work of an
old and experienced artist who, in the
nihilism of this pagan rite, has glimpsed his
own mortality. CC

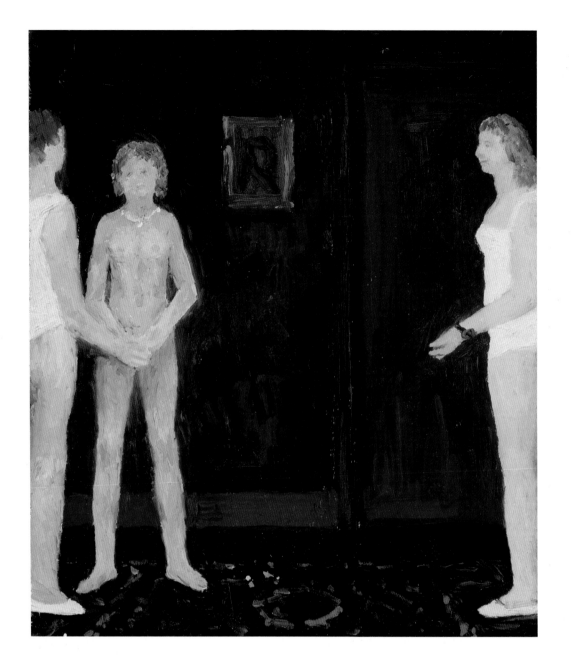

58 The Argument

1983
Oil on board, 30.5 × 26 cm
Artist's estate

59 Nocturne

Signed and dated 1983
Oil on board, 12 × 23.5 cm
Artist's estate

60 Seascape with Rainbow

Signed and dated 1983
Oil on board, 13.3 × 27.3 cm
Artist's estate

In *Seascape with Rainbow* and
Nocturne Eurich exhibits the
intimiste sensibility of those late
nineteenth-century *plein-air*
painters, such as Theodore
Roussel, Paul Maitland or even the
young Walter Sickert, who could
create a masterpiece on a cigar-
box lid. *Gathering Storm* (cat. 44),
Dymchurch Sands (cat. 47), *Mirage*
(cat. 63) and *Beach VII* (cat. 68) all
fit into this category. PS

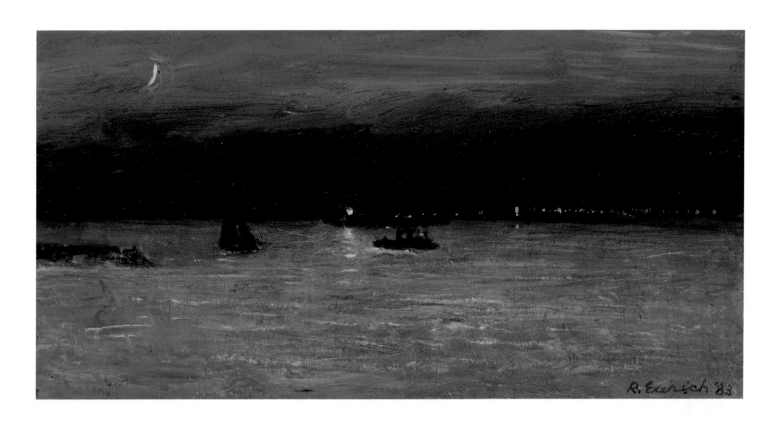

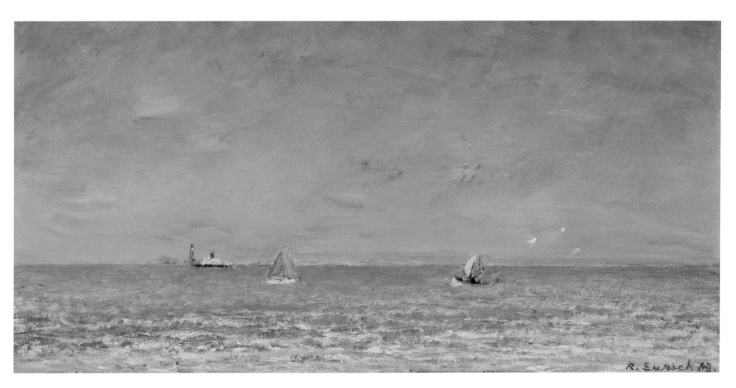

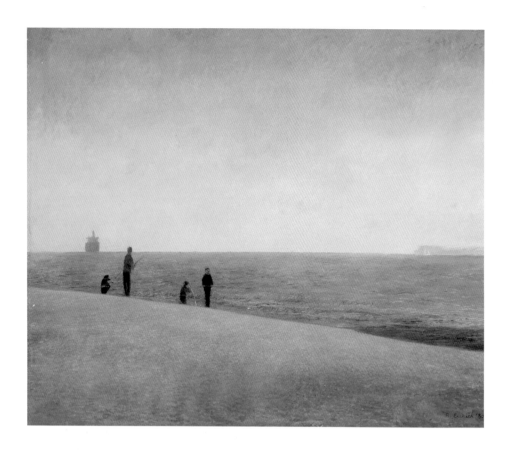

61 Solent Fishing

Signed and dated 1980
Exhibited at Ash Barn Gallery, 1984
Oil on board, 63.5 × 76.2 cm
Artist's estate

The strength of Eurich's compositional powers are apparent in this simple view. CC

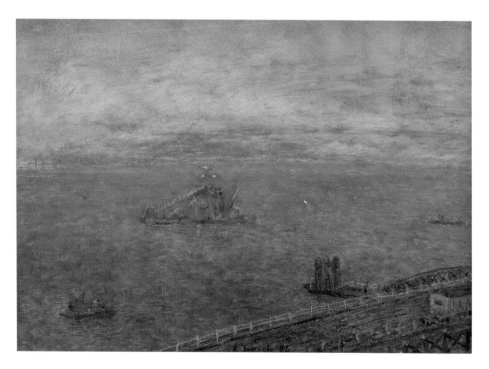

62 The Dredger

Signed and dated 1984
Exhibited at Ash Barn Gallery, 1984; The Fine Art Society, 1991
Oil on board, 22.9 × 31.8 cm
Artist's estate

Eurich cared little for romantic subjects and few could be more prosaic than a dredger, here working in a twilight gloom beneath an iridescent sunset. CC

63 The Quetzel Dance

Signed and dated 1985
Exhibited at the Royal Academy, 1986
Oil on board
39.4 × 48.9 cm
Artist's estate

The Quetzel Dance was inspired by a press
photograph that struck Eurich as being out
of the ordinary. CC

64 Cynthia

Signed and dated 1985
Oil on board, 15.2 × 2.7 cm
Artist's estate

The technique adopted in this timeless
likeness is reminiscent both of a mummy
portrait and of a Kees van Dongen, given the
sitter's direct stare and the absence of any
spatial context. The identity of Cynthia is
unknown. CC/EC

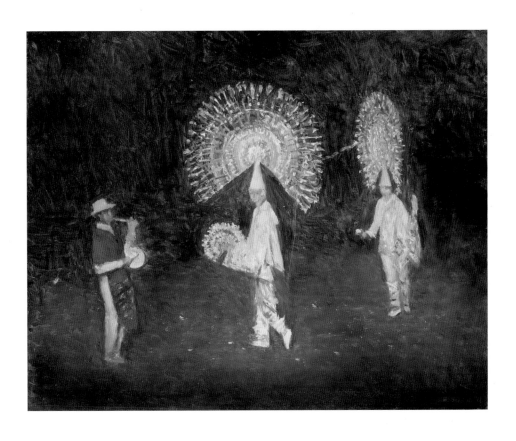

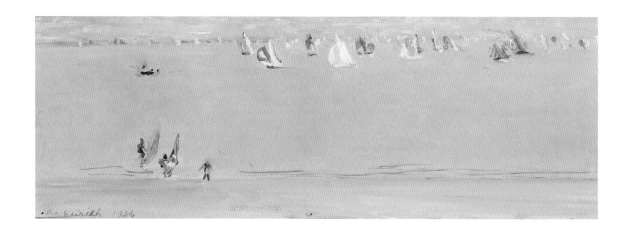

65 Beach II

Signed and dated 1986
Oil on board, 11.4 × 32.4 cm.
Artist's estate

In *Beach II* the narrative interest is created by a flotilla of small yachts scudding from right to left, whilst in *Beach VI* (cat. 67), of the same date, visual interludes are provided, like musical notes, by the little figures on the shoreline, silhouetted against the water's edge. PS

66 Blizzard

Signed and dated 1985
Oil on board, 20.3 × 33 cm
Artist's estate

67 Beach VI

Signed and dated 1986
Oil on board, 10.2 × 31.1 cm
Artist's estate

68 Beach VII

Signed and dated 1986
Oil on board, 22.9 × 27.9 cm
Artist's estate

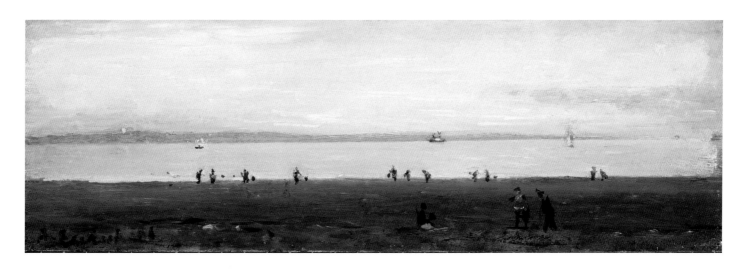

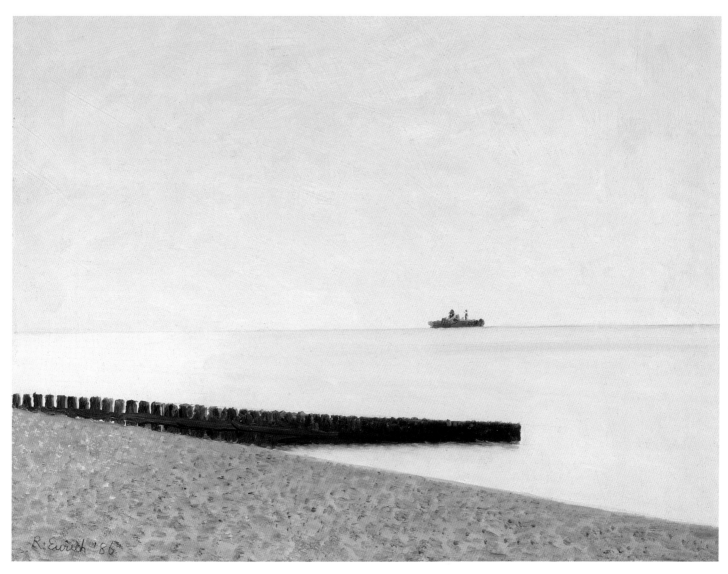

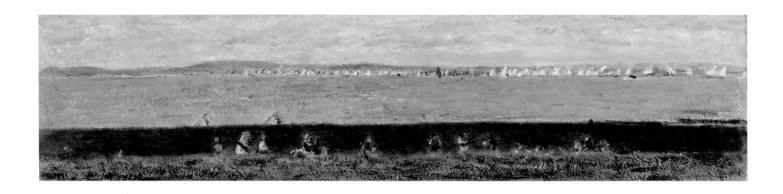

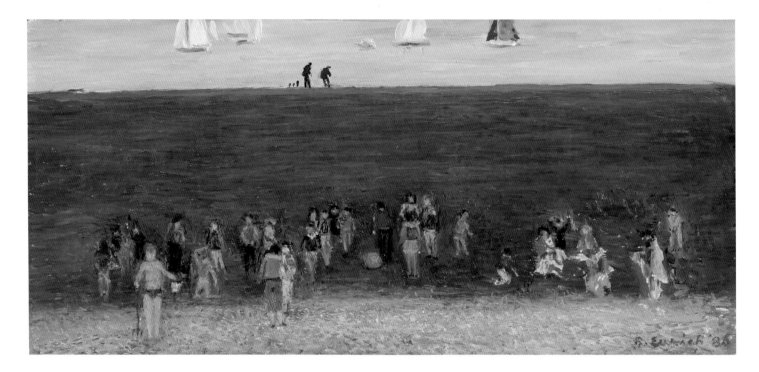

69 Dark Beach

Signed and dated 1986
Oil on board, 8.9 x 35.6 cm
Artist's estate

Eurich enjoyed unexpected contrasts, in this
instance of a shoreline, left dark by the
receding tide, against the light coastal waters.
CC

70 Figures on the Beach

Signed and dated 1986
Oil on board, 15.9 x 36.2 cm
Artist's estate

In his later years Eurich enjoyed observing
the activities of other people on the beach.
The way in which he subsequently painted
them draws out an intriguing tension
between these anonymous figures and their
setting, as can be seen both in this painting
and in *Early Morning, Lepe* (cat. 73). CC

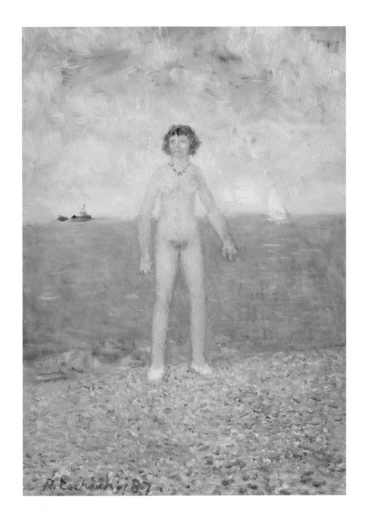

71 The Girl

Signed and dated 1987
Oil on board, 31.8 x 22.9 cm
Artist's estate

This painting, like *The Black Tent* (cat. 57) and
The Argument (cat. 58), is rooted in a moment
of starkly, and rather shockingly direct,
observation. In such moments something,
whether in colour or composition, struck
Eurich as being out of the ordinary, even in
its very 'ordinariness'. He depicted these little
incidents with complete detachment, benignly
viewing the participants not so much as
individuals but rather as colour-notes and
accents. There is no curiosity, no sense of
voyeurism, just a record of a fleeting vision.
PS

72 Flight of Birds over the Sea

Signed and dated 1988
Oil on board, 48.3 x 71.1 cm
Artist's estate

73 Early Morning, Lepe

Signed and dated 1987
Oil on board, 41.9 × 61 cm
Artist's estate

74 Broken Cloud

Signed and dated 1988
Oil on board, 48.3 × 55.9 cm
Artist's estate

Eurich's influence as a teacher at Camberwell is hard to trace, but a picture such as this evidently had much to offer a younger fellow RA, Fred Cuming, who remembers Eurich with affection and respect. Even in his eighties Eurich remained open to new ideas, and may himself have derived inspiration from such committed colleagues as Cuming. EC

75 The Edge of the Woods

Signed, 1989
Oil on board, 7.6 × 40.6 cm
Artist's estate

Like *The Burning Bush* (1984; cat. 46), this eerie painting is set on the margin of woodland, but here the scene is populated by only three figures and a chilly mist seeps across the landscape. Eurich grew progressively deaf with age, and perhaps the loneliness of this painting expresses something of his sense of isolation. CC

76 Stormy Sea

Signed and dated 1989
Oil on board, 26.7 × 61 cm
Artist's estate

Eurich was a master at painting water in every mood and the turbulence of the sea in this picture vividly indicates the strength of the gale. CC

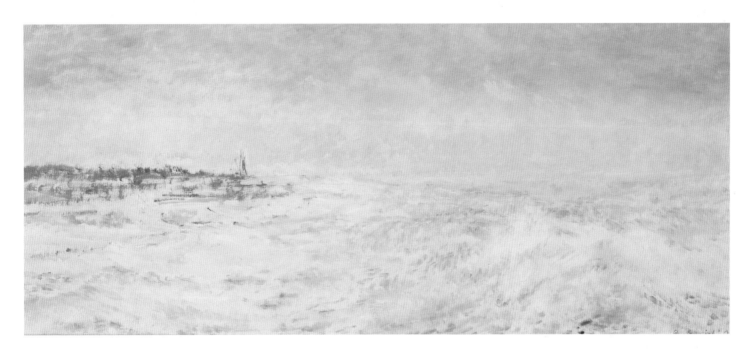